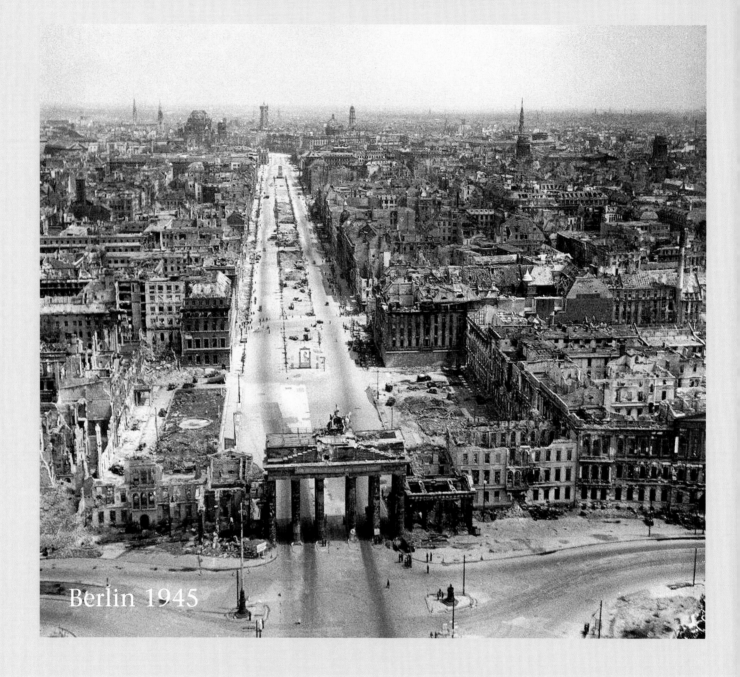

Berlin 1945

Blick vom Brandenburger Tor zur Stadtmitte im Sommer 1945 (oben) und Ansicht vom Potsdamer Platz zur Stadtmitte um 1950 (rechts)

Durch den Luftkrieg während des 2. Weltkriegs (1939–45) und den unsinnigen Häuserkampf während der Eroberung Berlins durch die Rote Armee vom 21. April bis 2. Mai 1945 wurden 50 000 Menschen getötet, 39 % des Wohnungsbestandes der Stadt (612 000 Wohnungen), mehr als 26 km² Stadtraum und 65 % der Industrieanlagen zerstört.

View from the Brandenburg Gate toward the city center in the summer of 1945 (above) and view from the Potsdamer Platz toward the city center around 1950 (right)

The air raids during the Second World War (1939–45) and the senseless house-to-house battles from 21st April to 2nd May as the Red Army took Berlin in 1945 resulted in the deaths of 50,000 people, and 39% of the city's housing stock (612,000 apartments), more than 26 square kilometres of urban land and 65% of the city's industrial premises were destroyed.

4

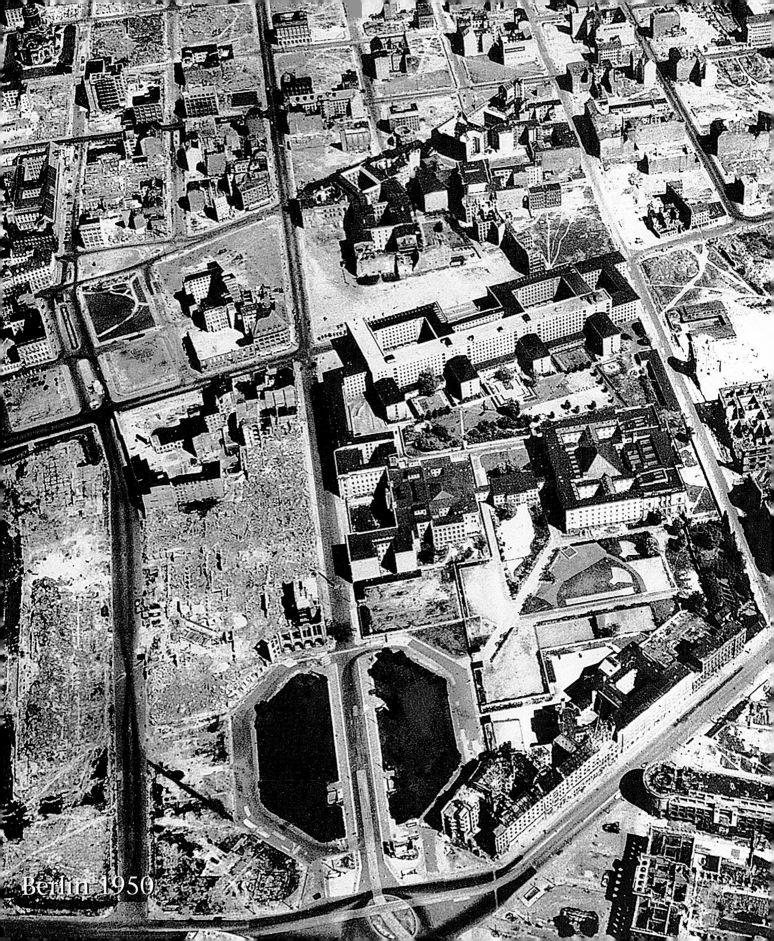
Berlin 1950

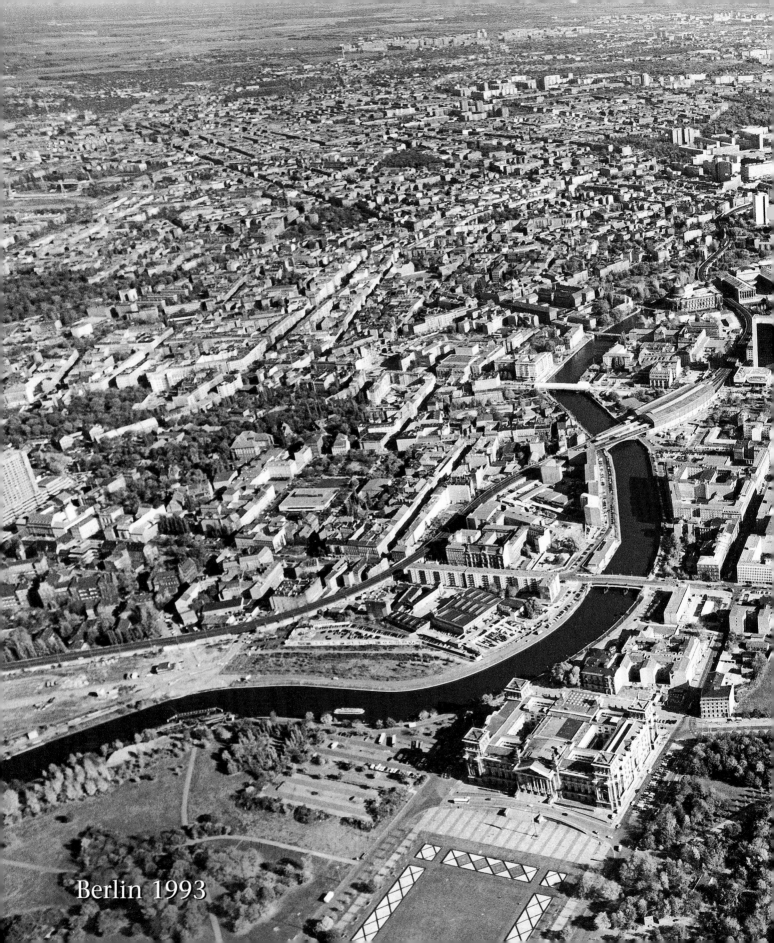
Berlin 1993

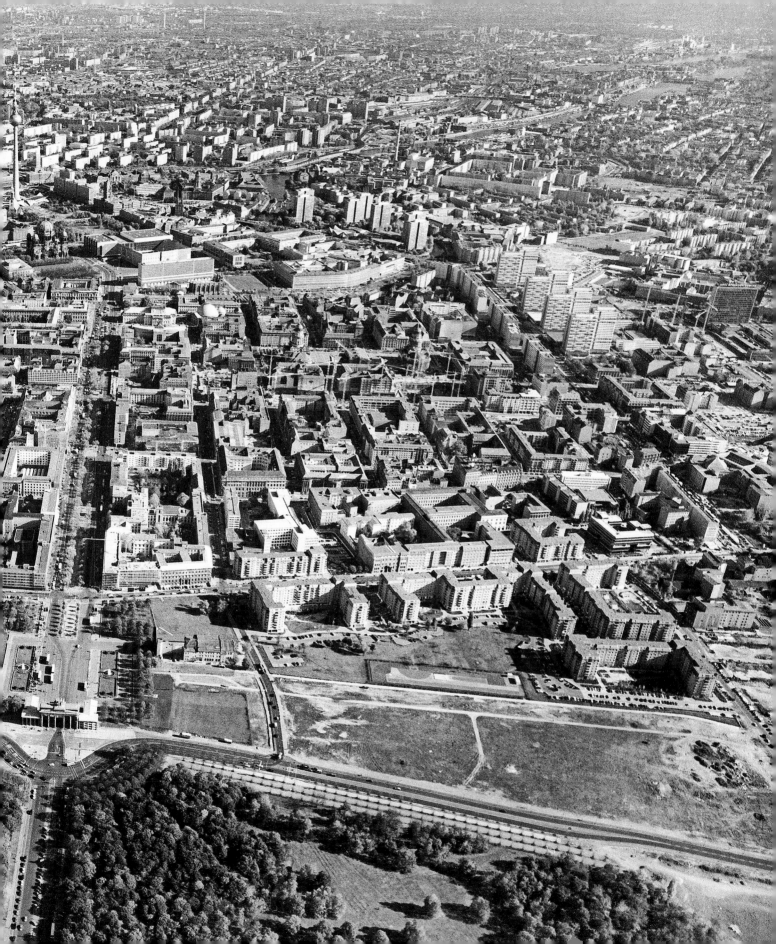

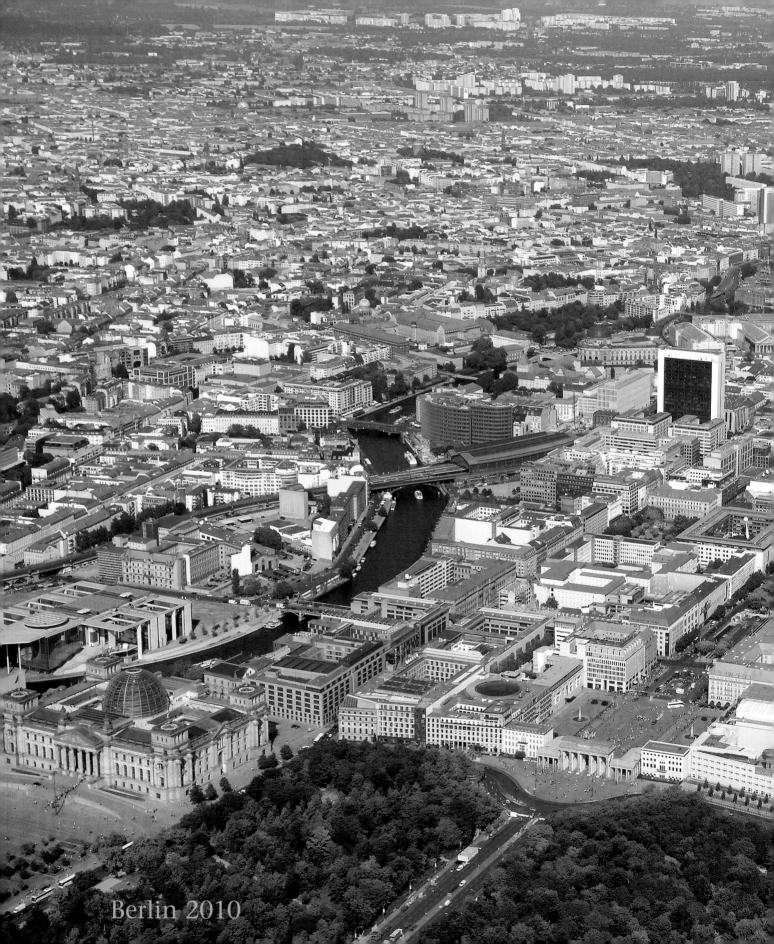

Berlin 2010

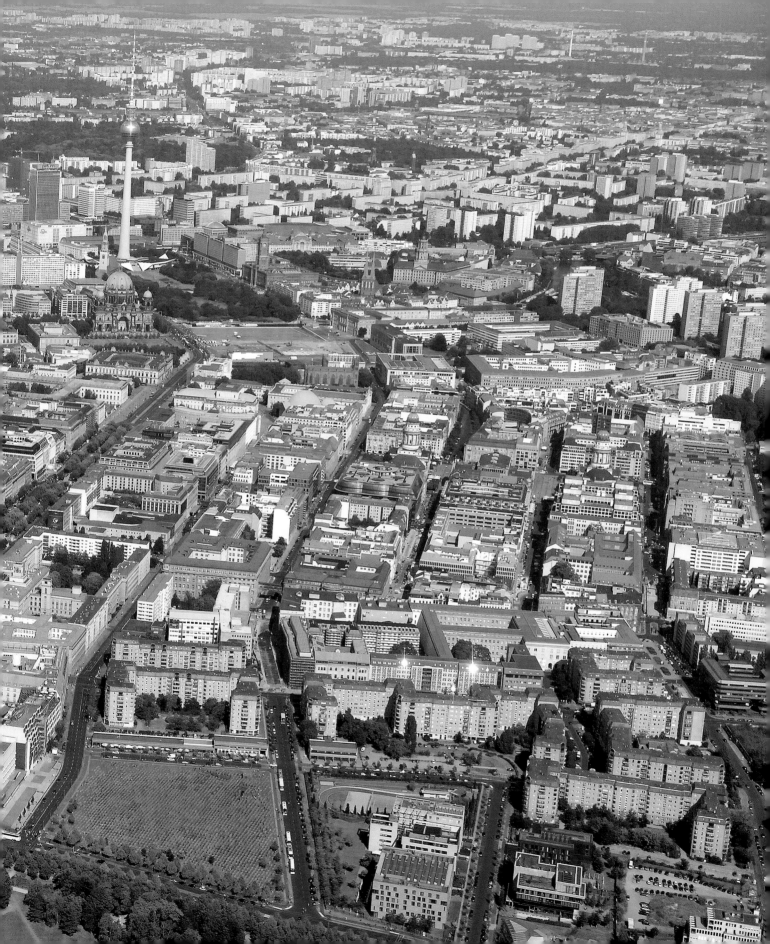

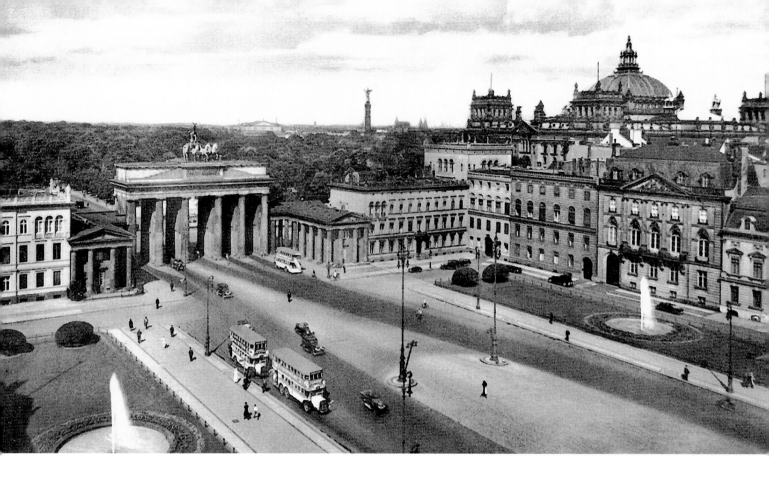
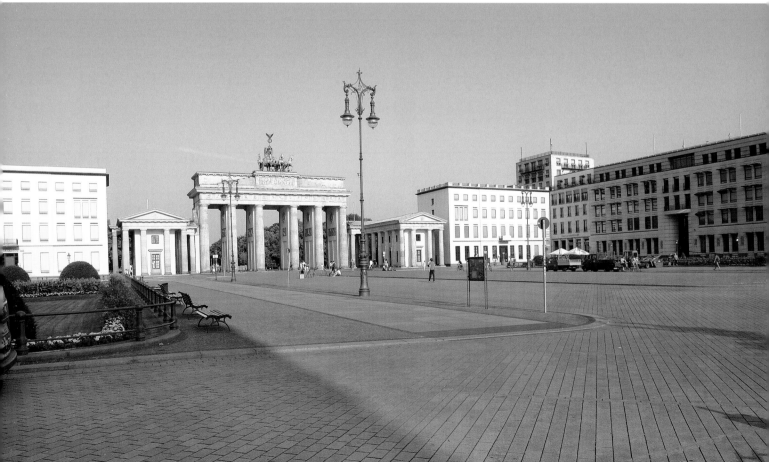

BERLIN

gestern und heute

yesterday and today

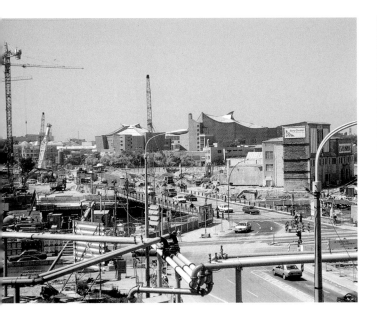
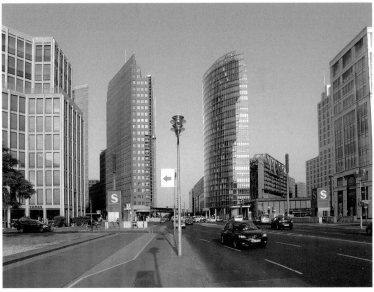

Michael Imhof Verlag

Inhalt

contents

Bildnachweis/*Images*: alle Fotos Michael Imhof und Michael Imhof Verlag mit Ausnahme von:

akg-images: S. 117 unten

akg-images/Reimer Wulf: S. 60 unten

Bundesarchiv, Bild 175-V00-02081/Klaus Lehnartz: S. 97

Helmut Caspar, Berlin: S. 29 unten, 73 unten links, 116 unten

Denkmalamt Berlin: S. 5, 22 (Bittner), 32 oben, 37 oben, 38 oben, 60 unten, 102 unten links, 110 oben, 111 oben links, 111 Mitte

Landesarchiv Berlin: S. 17, 115 Mitte

SLUB Dresden/Deutsche Fotothek: Titelbild oben rechts, S. 6/7 (Lothar Willmann), 8/9, 108/109, 118/119

ullstein bild: S. 115 oben links (dpa), oben rechts (AP), 116 oben (Ritter)

Günter Zint: S. 95 oben links, oben rechts, Mitte, 102 unten rechts, 103 unten, 104 links und unten, 105 oben rechts, 114 oben und unten rechts, 115 unten links

Es war nicht in allen Fällen möglich, die Rechteinhaber zu ermitteln. Sollten Ansprüche bestehen, dann werden diese entsprechend der üblichen Honorarsätze abgegolten.

© 2017 (1. Auf. 2010) Michael Imhof Verlag GmbH & Co. KG
Stettiner Straße 25, D-36100 Petersberg
Tel. 0661/9628286; Fax 0661/63686
www.imhof-verlag.de

Text: Michael Imhof Übersetzung/*Translation*: Jonathan Darch und Linz Übersetzungen, Nürnberg
Gestaltung und Reproduktion/*Design and reproduction*: Michael Imhof Verlag
Druck/*Print*: Himmer GmbH Druckerei, Augsburg

Printed in EU

ISBN 978-3-86568-609-1

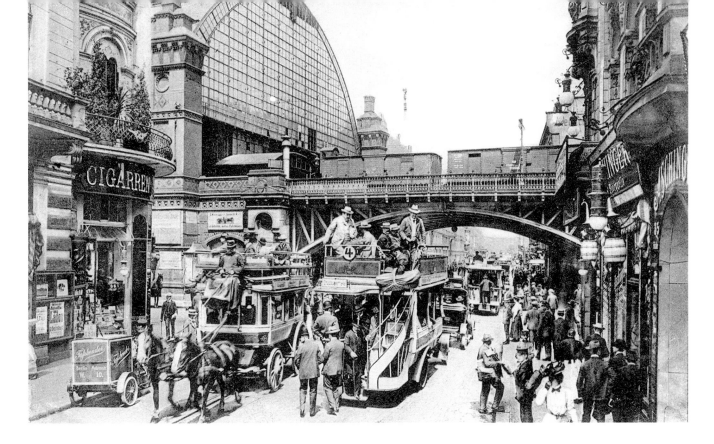

Bahnhof Friedrichstraße um 1910 und heute *Friedrichstraße Train Station ca. 1910 and today*

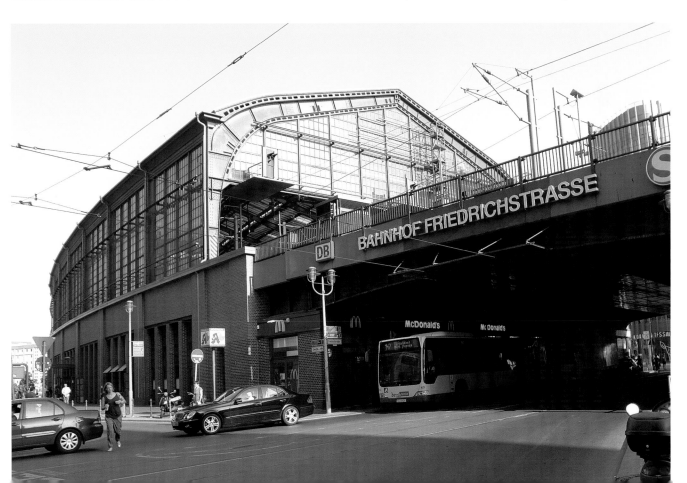

Das mittelalterliche Zentrum

Um 1170 entstanden beiderseits der Spree an einem günstigen Flussübergang die Städte Cölln, am Südufer auf einer von einem Nebenarm der Spree gebildeten Insel, und Berlin, am Nordufer der Spree. St. Nikolai bildete die Keimzelle von Berlin, St. Petri diejenige Cöllns. Gegen 1250 wurde Berlin um die Neustadt mit der Marienkirche erweitert. Die erste Erwähnung Cöllns erfolgte 1237, diejenige Berlins 1244. Zu diesem Zeitpunkt besaßen bereits beide Orte Stadtrecht. Die Doppelstadt – seit 1307 zu einer Bundesstadt zusammengeschlossen – entwickelte sich rasch zur wichtigsten Ortschaft der Mark Brandenburg und war seit dem 14. Jahrhundert Teil der Hanse. Seit dem späten 13. Jahrhundert erbaute man die Stadtmauer mit doppeltem, von der Spree gespeistem Graben und der aus Feldsteinen errichteten Mauer. Um 1450 zählte man in Cölln 300 und in Berlin 700 Häuser, in denen insgesamt 5000 bis 6000 Menschen lebten.

Von den baulichen Zeugnissen der älteren Teilstadt Cölln sind nach schweren Kriegszerstörungen im 2. Weltkrieg und den Flächenabrissen in den 1960er-Jahren nur noch Ansätze

The historical city centre

Two towns emerged around 1170 on either side of the Spree at a convenient river crossing: Cölln, on the south bank on an island formed by one of the Spree's tributaries, and Berlin, on the north bank of the Spree. St. Nikolai formed the nucleus of Berlin, St. Petri that of Cölln. Shortly before 1250, Berlin was extended by the addition of the new town with its Marienkirche (St. Mary's Church). The first mention of Cölln was made in 1237, that of Berlin in 1244. By this time, both places already possessed city rights. The twin city – having merged into one in 1307 – quickly grew into the most important place in the Mark of Brandenburg and from the 14th century was part of the Hanseatic League. In the late 13th century, work began on the city wall, consisting of a double moat, fed by the Spree, and the wall itself, built in stone. Around 1450, Cölln had 300 houses and Berlin 700, which were home in total to between five and six thousand people.

Following major destruction in the Second World War and wholesale land clearance in the 1960s, only signs of the architectural heritage of the older part of Cölln can still be traced.

Westliche Ansicht der „Chur. Fürstl. Res. St. Berlin: v. Cölln" von Caspar Merian, 1652
A Vorderschloss; B Schloss, Rückseite; C Kurfürstenzimmer; D Wendelstein; E Schlosskirche; F Galler; G Wasserkunst; H Dom; I St. Nikolaus; K Rathaus; L Cöllner Rathaus; M Reithaus; N St. Peter; O St. Marien; P Spandauer Tor; Q Heilig-Geist-Kirche; R Garten; S Brücke; T Alte Münze

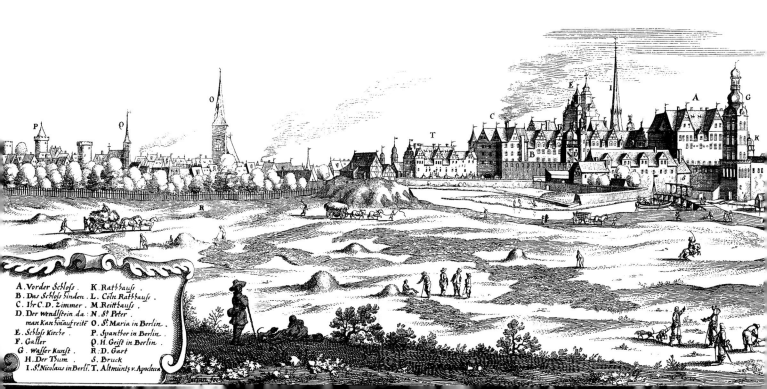

nachvollziehbar. Das ehemals bedeutendste Gebäude – die Petrikirche an der Gertraudenstraße, zuletzt 1846–53 nach Entwurf von Heinrich Strack neugotisch erneuert – wurde nach Kriegsschäden 1960–64 beseitigt. An das 1297 gegründete Kloster der Dominikaner erinnert der Name der Brüderstraße. Die Kirche des Dominikanerklosters bezog man 1536 als Domkirche und Grablege der Hohenzollern in den kurfürstlichen Hofbereich ein. Außerhalb der Stadt lag unmittelbar vor dem Gertraudentor das ebenfalls seit dem späten 13. Jahrhundert bestehende Gertrauden-Spital, das dem späteren Spittelmarkt den Namen gab. Das Cöllnische Rathaus lag an der Ecke Breite Straße/Gertraudenstraße.

Geprägt wurde das mittelalterliche Stadtbild des jüngeren Stadtteils Berlin von seinen Pfarrkirchen, die gleichzeitig die Märkte der Stadt markierten: von der Nikolaikirche, die in den 1240er-Jahren romanisch vollendet und später gotisch erneuert wurde, und von der jüngeren Marienkirche, mit der um 1270 begonnen wurde. Das Rathaus verlegte man Mitte des 13. Jahrhunderts genau zwischen die beiden Märkte an die Spandauer Straße, nachdem das ältere Rathaus noch östlich von St. Nicolai gelegen hatte. Kurz vor 1250 siedel-

What was formerly the most significant building, the Petriskirche (St. Peter's Church), which had last been restored in 1846–53 to a Neo-Gothic design by Heinrich Stack, was demolished in 1960–64, having been badly damaged in the War. The name 'Bruderstrasse' (Brothers Street) is a reminder of the Dominican monastery that was founded in 1297. The monastery's church was moved in 1536 into the grounds of the electoral court as the cathedral and final resting place of the Hohenzollerns. Outside of the city, just beyond the Gertraudentor (Gertrude Gate), stood the Gertrauden-Spital (Gertrude Hospital), also dating from the late 13th century, which gave what later became 'Spittelmarkt' its name. Cölln's Rathaus (town hall) stood on the corner of Breite Straße (Broad Street) and Gertraudenstraße (Gertrude Street).

The medieval appearance of the newer part of Berlin was dominated by its parish churches, which at the same time marked the city's market squares, These were the Nikolaikirche (St. Nicholas's), which was finished in Romanesque style in the 1240s and later remodelled with a Gothic look, and the newer Marienkirche (St. Mary's), on which work began around 1270. While the old Rathaus (town hall) had been located to the east

View of Berlin in 1652, Printing by Caspar Merian
A Vorderschloss; B Palace, back; C Kurfürstenzimmer; D Wendelstein; E Palace church; F Galler; G Wasserkunst; H Cathedral;
I St. Nikolaus; K Guildhall; L Guildhall of Cölln; M Reithaus; N St. Peter; O St. Marien; P Spandauer Tor; Q Heilig-Geist-Kirche; R Garten;
S Bridge; T Alte Münze

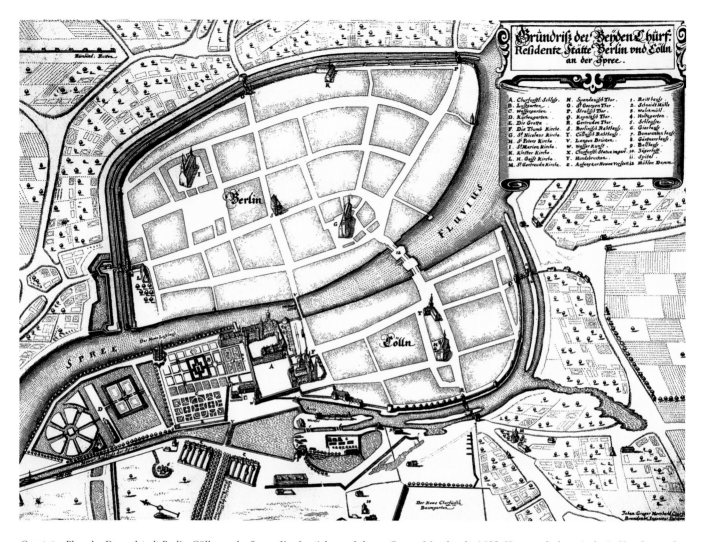

Geosteter Plan der Doppelstadt Berlin-Cölln an der Spree, Kupferstich von Johann Gregor Memhardt, 1652. Hervorgehoben sind – in Vogelperspektive dargestellt – die Rathäuser in der Mitte von Berlin und Cölln sowie die Kirchen St. Nicolai, St. Marien und an der Stadtmauer die Franziskanerkirche (oben) und die Heiliggeistkapelle (links) sowie St. Petri in Cölln. Der Schlossbereich befindet sich links unten.

Overhead plan of the twin city of Berlin-Cölln on the Spree. Copper etching by Johann Gregor Memhardt, 1652. Emphasised and portrayed in birds-eye view are the town halls in the middle of Berlin and Cölln, the St. Nicolai and St. Marien churches, and, next to the city wall, the Franciscan Church (top) and the Chapel of the Holy Spirit (left), plus St. Peter's Church in Cölln. The palace area is bottom left.

Legende

A Churfürstl. Schloß	*H St. Peters Kirche*	*Q Kepniksch Thor*	*Y Hundsbrucken*	*6 Gieshauß*
B Lustgarten	*I St. Marien Kirche*	*R Gertruden Thor*	*Z Anfang zur Newen Vor-statt*	*7 Bomerantznhauß*
C Wassergarten	*K Kloster Kirche*	*S Berlinisch Rahthauß*		*8 Gärtnershauß*
D Küchengarten	*L H. Geist Kirche*	*T Cöllnisch Rahthauß*	*1 Reitthauß*	*9 Ballhauß*
E Die Grotta	*M St. Gertraudn Kirche*	*V Langen Brücken*	*2 Schneidt Mühle*	*10 Jägerhoff*
F Die Thumb Kirche [Domkirche]	*N Spandauisch Thor*	*W Wasser Kunst*	*3 Walckmühl*	*11 Spital*
	O St. Georgen Thor	*X Churfürstl. Statua im gart.*	*4 Holtzgarten*	*12 Mühlen Damm*
G St. Nicolaus Kirche	*P Stralisch Thor*		*5 Schleuße*	

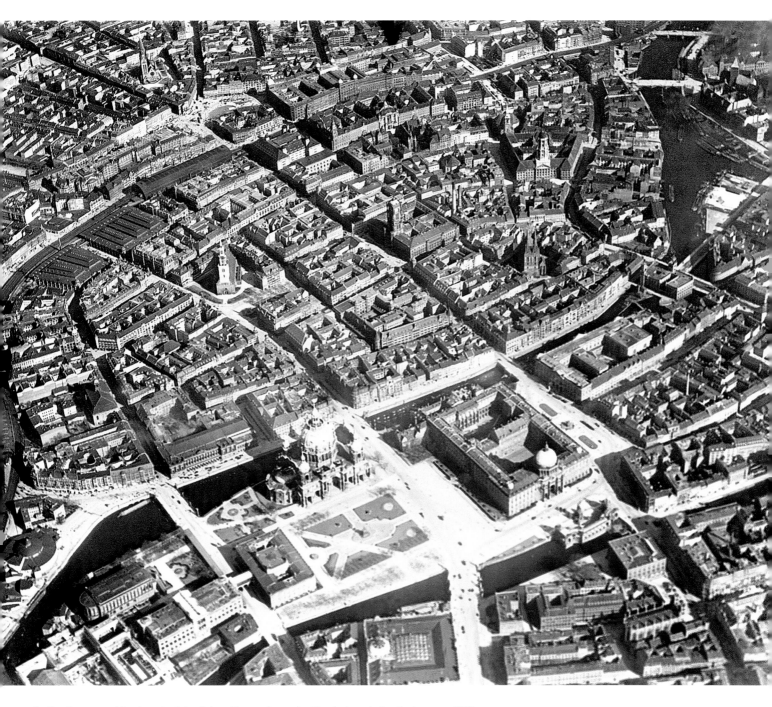

Berlin, Gesamtansicht der mittelalterlichen Kernstadt aus der Vogelschau, Luftaufnahme um 1920

Berlin, aerial view of the medieval city center around 1920

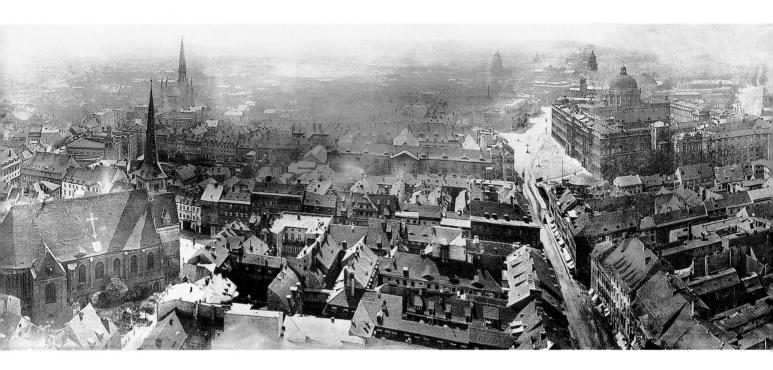

Blick vom Rathausturm 1868 auf Nikolai- und Petrikirche, Schloss, Alten Dom, Neuen Markt und Marienkirche

Blick vom Rathausturm um 1900 mit Neuem Dom und Neubauten auf der Museumsinsel und rund um den Neuen Markt

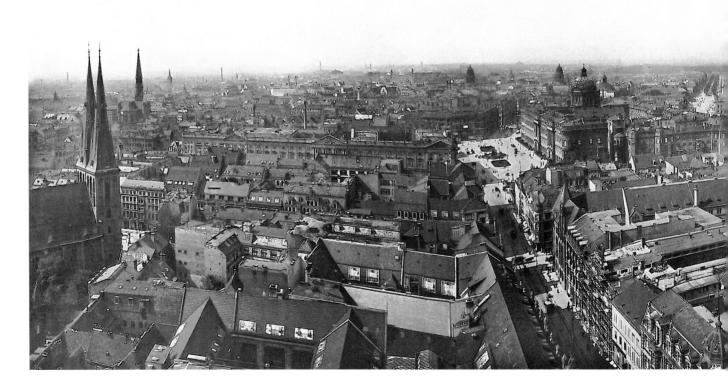

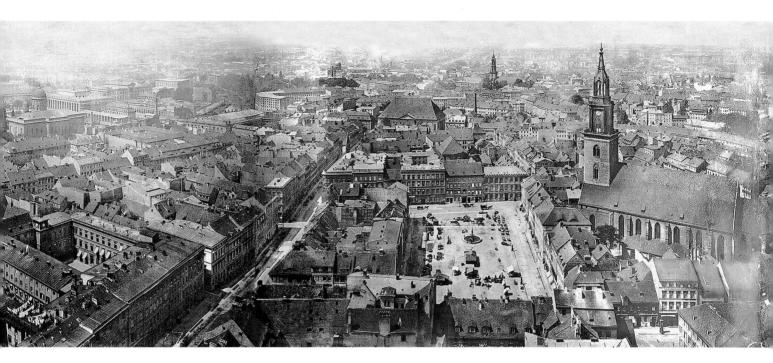

View from the tower of the "Rotes Rathaus" toward St. Nicholas' Church, St. Peters' Church and St. Maries' Church in 1868

View from the tower of the "Rotes Rathaus" with the new Cathedral and museums around 1900

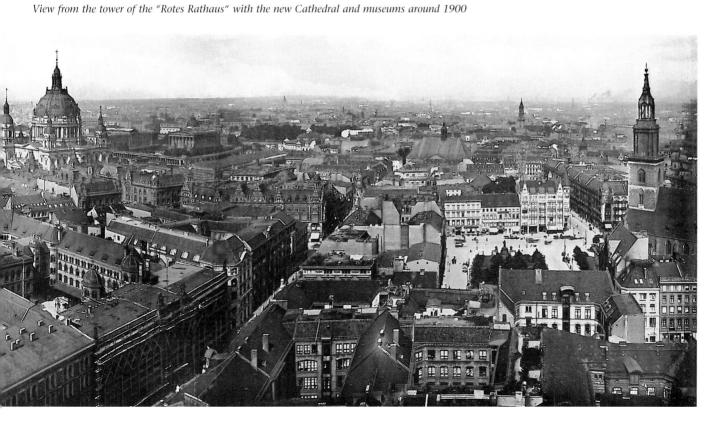

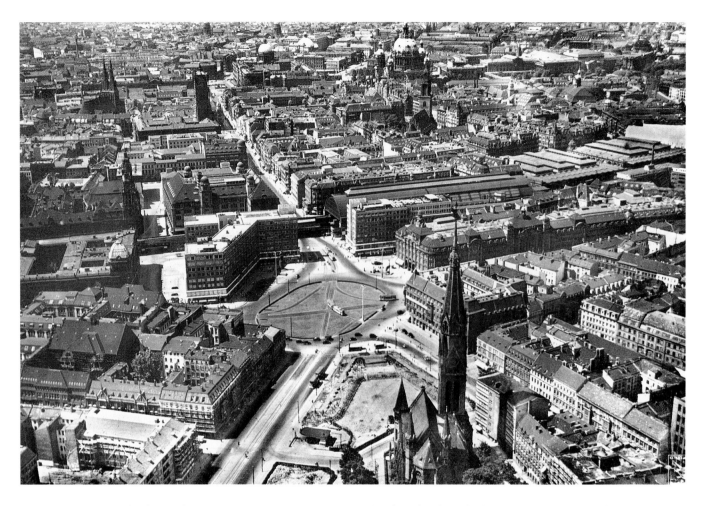

Blick über den Alexanderplatz nach Westen um 1930 *View from the Alexanderplatz toward the west around 1900*

ten sich in unmittelbarer Nähe die Franziskaner an, deren stattliche frühgotische Klosterkirche als Kriegsruine erhalten ist.

Das mittelalterliche Berlin, das noch bis zu seiner Zerstörung im 2. Weltkrieg mit seinem Straßensystem erhalten war, ist fast völlig verschwunden. Durch den Wiederaufbau als Hauptstadt der DDR entstanden – begünstigt durch das sozialistische Bodenrecht der DDR – große Freianlagen mit Grünflächen rund um den Fernsehturm, sechs- bis zehnspurige Durchgangsstraßen (z. B. Karl-Marx-Allee, Leipziger Straße) und monotone Wohnblocks anstelle der kleinteiligen historischen Bebauung. Trotz der nur wenigen erhaltenen älteren Gebäude und der Baumaßnahmen seit dem Mauerfall 1989 ist die Struktur des alten Berlin

of St. Nikolai, a new one was built in the middle of the 13th century on Spandauer Straße, exactly half-way between the two markets. Shortly before 1250, the Franciscan monks settled very close to here and their stately, early Gothic monastery church has been retained as a ruin of war.

Medieval Berlin, which with its road system had remained intact until it was destroyed in the Second World War, has almost completely disappeared. Helped by the GDR's socialist land laws, reconstruction as the capital of East Germany produced large open areas and parks around the television tower, six to ten-lane thoroughfares (e.g. the Karl Marx Allee and Leipziger Straße) and monotonous blocks of flats in place of the small-scale, piecemeal historic development. While only a few of the older buildings and constructions remain since the fall of the Wall in 1989, the struc-

20

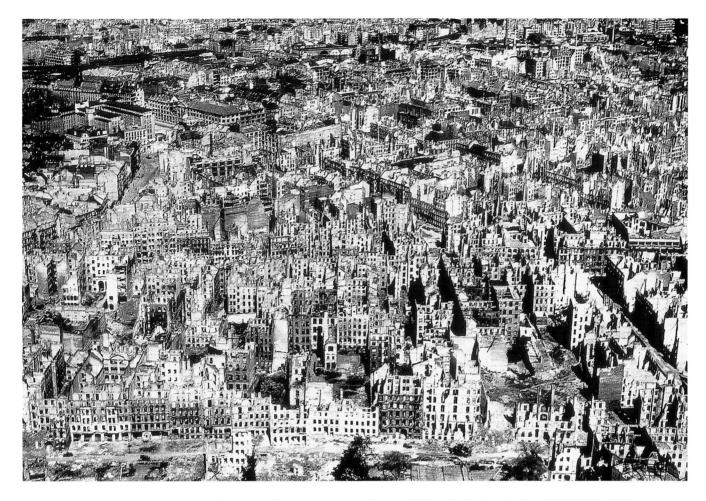

Zerstörtes Stadtzentrum von Berlin nach dem 2. Weltkrieg 1945

Destroyed City of Berlin after the Second World War 1945

mit Hilfe der verbliebenen Objekte jedoch noch nachvollziehbar.

Bereits Ende der DDR-Zeit hatte sich der Wunsch nach einem „historischen" Gesicht der Stadtmitte geregt, sodass zwischen 1980 und 1987 anlässlich der 750-Jahr-Feier der Stadt Berlin der Wiederaufbau des brachliegenden Nikolaiviertels mit der als Ruine belassenen Nikolaikirche vollzogen wurde. Man wählte eine kleinteilige Architektur in Großplattenbauweise oder aus Fertigteilen mit Giebelgruppen, die sechs erhaltene Wohnhäuser (darunter das Knoblauchhaus von 1759/60 und 1835) sowie rekonstruierte Gebäude auf einem mittelalterlich anmutenden Stadtgrundriss mit schmalen, unregelmäßig verlaufenden Gassen ergänzten. Rekonstruiert, jedoch an verändertem Ort wiederaufgebaut, wurden unter anderem die Gast-

ture of old Berlin can nevertheless still be traced with the help of the surviving properties.

As soon as the GDR era had come to an end, a desire emerged to give the city centre an 'historic' visage. Between 1980 and 1987, therefore, to coincide with Berlin's 750ᵗʰ anniversary, the reconstruction was undertaken of the derelict Nikolaiviertel (Nikolai Quarter), including the Nikolaikirche (St. Nicholas's Church), which had previously been left in ruins. The planners chose a small-scale form of architecture in large panel construction or using prefabricated components with groups of gables. These complimented six preserved residential properties (including the Knoblauchhaus dating from 1759/60 and 1835) and several reconstructed buildings in an urban layout with a medieval air and narrow, irregular lanes. Buildings reconstructed at this time included,

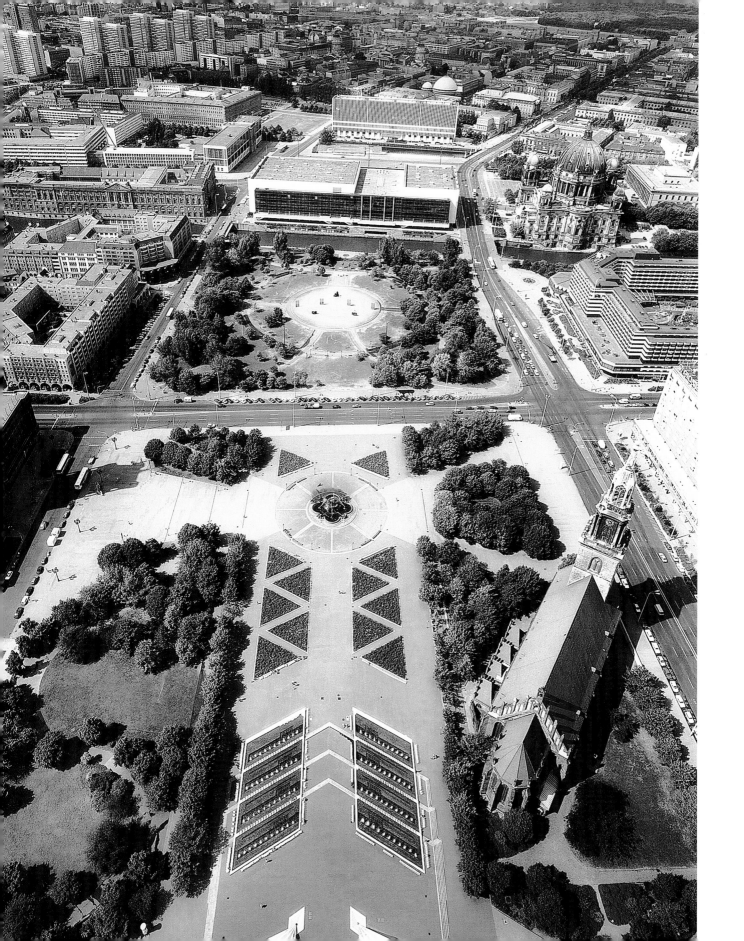

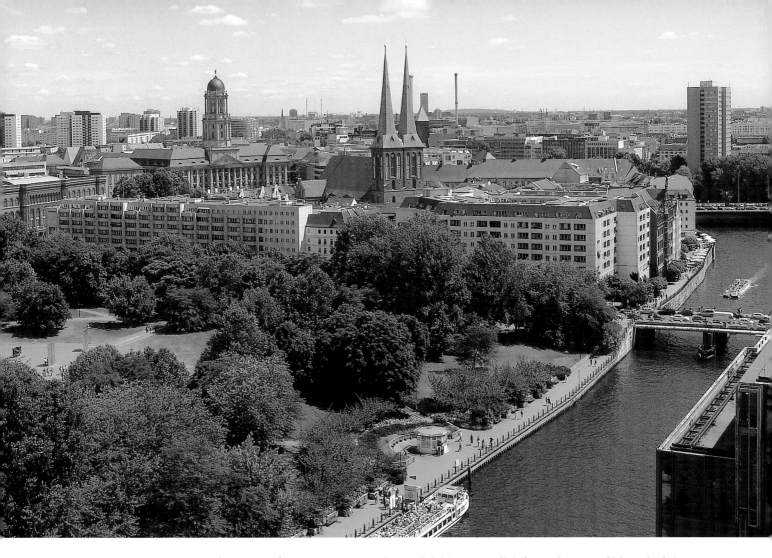

oben: Nikolaiviertel. Um die Nikolaikirche befand sich die älteste An-siedlung Berlins, die 1228/30 zur Stadt erhoben wurde. Der Wieder-aufbau des im 2. Weltkrieg stark zerstörten Nikolaiviertels wurde erst 1987 abgeschlossen.
links: Blick vom Fernsehturm auf Marienkirche, Dom und Palast der Republik 1992

above: Nikolai Quarter. Berlin's first settlement – which attained city status between 1228 and 1230 – was located in the area surrounding the church of St. Nikolai (Nicholas). The reconstruction of the quarter of St. Nicholas, which was heavily destroyed during World War II, wasn't completed until 1987.
left: View from the Fernsehturm zu St. Maries' Church, Cathedral and Palast der Republik in 1992

stätte „Zum Nußbaum" (ursprünglich 15./16. Jahrhundert), die Gerichtslaube des Rathauses (ursprünglich um 1270 errich-tet, 1555 und in der Barockzeit verändert und 1871 abgebro-chen) und das Gasthaus „Zur Rippe" (um 1690 erbaut, 1935 abgebrochen). Das barocke Ephraim-Palais wurde – um eini-ge Meter westlich von seinem ursprünglichen Standort ver-setzt – unter Verwendung originaler Bauteile wiedererrichtet. Die Fassaden entlang der Propststraße und am Nikolaikirch-platz bzw. Mühlendamm sind Neuschöpfungen im Stil des 18. und 19. Jahrhunderts.

although rebuilt in a different location, the 'Zum Nußbaum' res-taurant ('The Nut Tree', originally 15th/16th century), the town hall's 'Gerichtslaube' ('Courtroom Gazebo', originally built around 1270, altered in 1555 and in the Baroque era and torn down in 1871) and the 'Zur Rippe' tavern ('Rib Inn', built around 1690, demolished 1935). The Baroque Ephraim Palace was rebuilt using parts of the original building, offset a few metres to the west of its original position. The façades along Propststraße (Provost Street) and onto Nikolaikirchplatz (St. Nicholas's Square) and Mühlen-damm are new creations in the style of the 18th and 19th century.

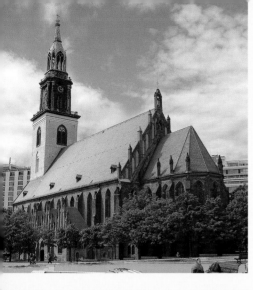

Marienkirche
(siehe S. 30, 31)
(s. page 30, 31)

Ehem. Berliner Rathaus
(siehe S. 34)
(s. page 34)

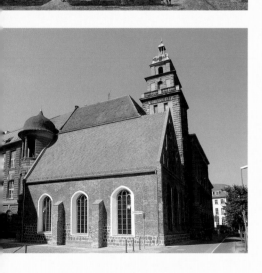

Neustädter Markt
(siehe S. 31)
(s. page 31)

Heilig-Geist-
Kirche,
15. Jahrhun-
dert

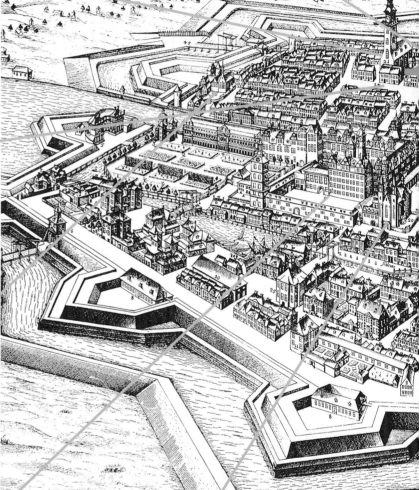

Ansicht von Berlin 1688, Stich von Johann Bernhard Schultz
Berlin in 1688, printing by Johann Bernhard Schultz

Breite
(siehe
(s. pag

Renaissance-Stadtschlosses
Renaissance city palace
(siehe S. 58–60)
(s. page 58-60)

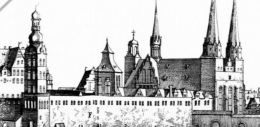

Dom, d. h. ehem. Dominikaner-
kirche, Ende 13. Jahrhundert
*Cathedral, i.e. the late 13th cen-
tury Dominican church*

Peterskirche
(siehe S. 50)
(s. page 50)

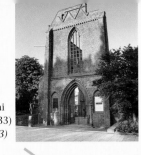

Franziskanerklosterkirche
(siehe S. 36, 37)
(s. page 36, 37)

olai
S. 33)
33)

Stadtmauer an der
Waisenstraße
*City wall alongside
Waisenstraße*

Klosterstraße
(siehe S. 39)
(s. page 39)

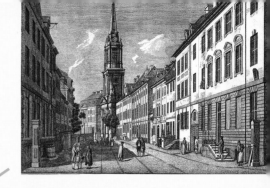

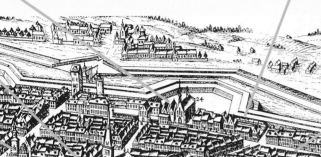

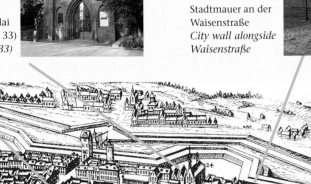

Molkenmarkt
(siehe S. 42)
(s. page 42)

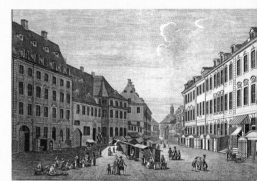

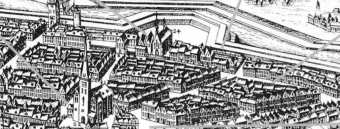

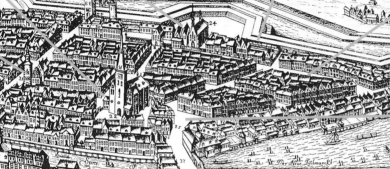

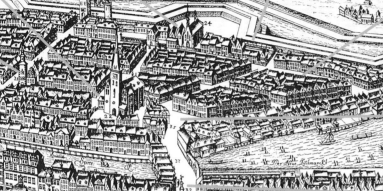

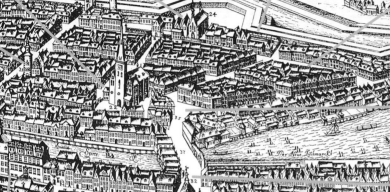

Cöllnisches
Rathaus
(siehe S. 50)
(s. page 50)

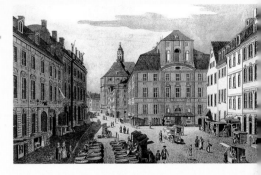

Peterskirche
(siehe S. 50)
(s. page 50)

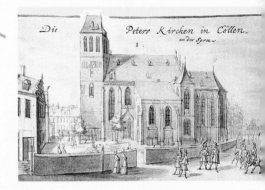

Leipziger Tor, 16. Jahrhundert

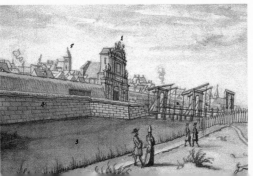

Spitalkirche
(siehe S. 52)
(s. page 52)

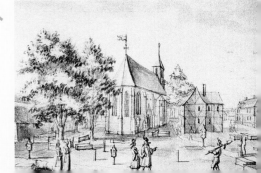

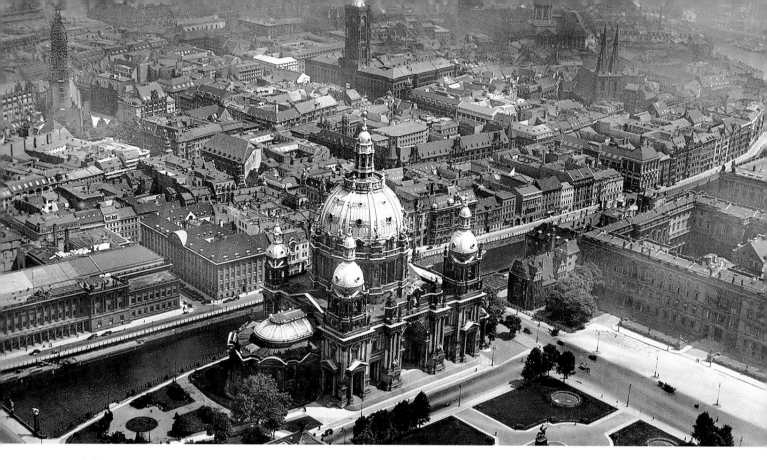

Blick um 1930 über den Dom auf das mittelalterliche Stadtzentrum mit der Börse (links vorne), der Marienkirche, dem Roten Rathaus, dem Stadthaus und der Nikolaikirche (rechts hinten) sowie dem Stadtschloss

Blick heute vom Berliner Dom auf das ehemalige mittelalterliche Stadt-zentrum mit Marienkirche, Rotem Rathaus, Stadthaus und Nikolaikirche

View ca. 1930 via the cathedral onto the medieval town centre with the stock market (front left), St. Mary's Church (rear left), the 'Red Town Hall' (centre), the Stadthaus and the Nikolaikirche (rear right) and the City Palace

View today from the cathedral toward the former medieval town centre with St. Mary's Church, the 'Rotes Rathaus', the Stadthaus and the Nikolaikirche

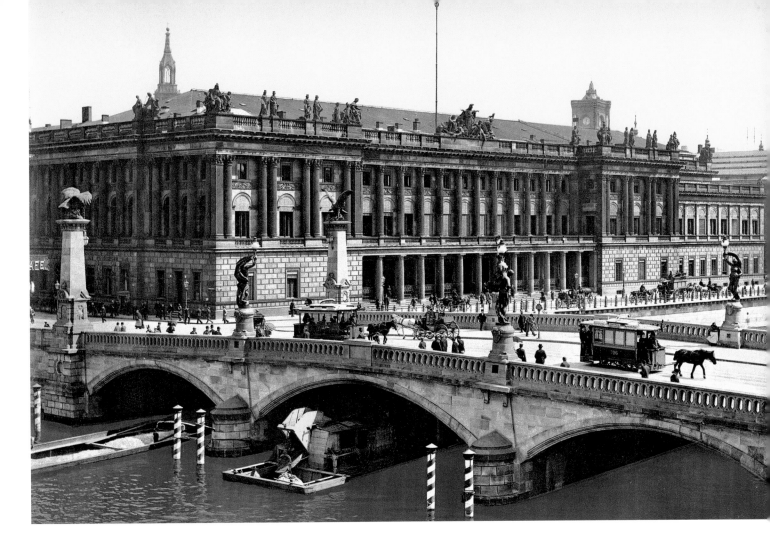

Prachtfassade der Börse an der Burg-
straße gegenüber dem Dom, 1859–63
nach einem Entwurf von Friedrich
Hitzig errichtet, Foto um 1900
(oben). Die heutige Situation zeigt
das sog. Spreepalais am Dom der
Architekten Nägele, Hofmann, Tiede-
mann & Partner von 2002 (rechts).

*Magnificent façade of the stock ex-
change on Burgstraße opposite of the
Cathedral, built 1859–63 by Friedrich
Hitzig, photo around 1900 (above).
Today's situation shows the so-called
Spreepalais at the Cathedral, built in
2002 by the architects Nägele, Hof-
mann, Tiedemann & Partner (right).*

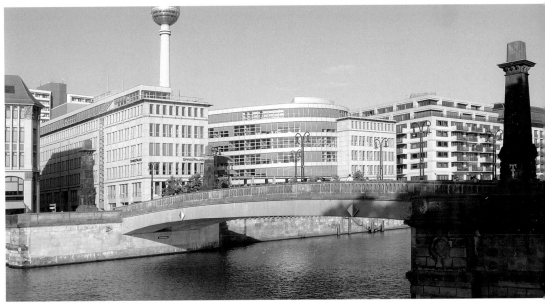

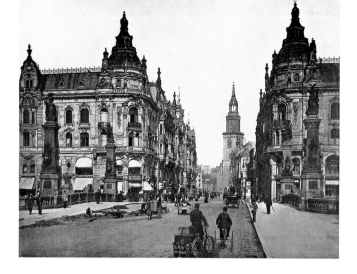

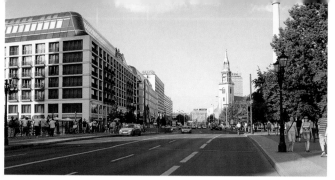

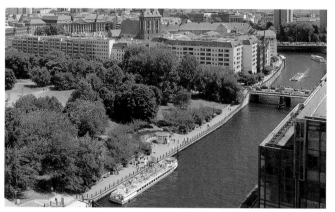

Ehem. Kaiser Wilhelmstraße bzw. Kaiser Wilhelmbrücke mit Blick zur Marienkirche um 1900 (oben) und heute (oben rechts)

Former Kaiser Wilhelmstreet and Kaiser Wilhelmbridge with view to the Marienchurch around 1900 (above) and today (above right)

Burgstraße und Lange Brücke im 18. Jahrhundert (unten) und heute (rechts)

Burgstraße and Lange Brücke 18th century (below) and today (right)

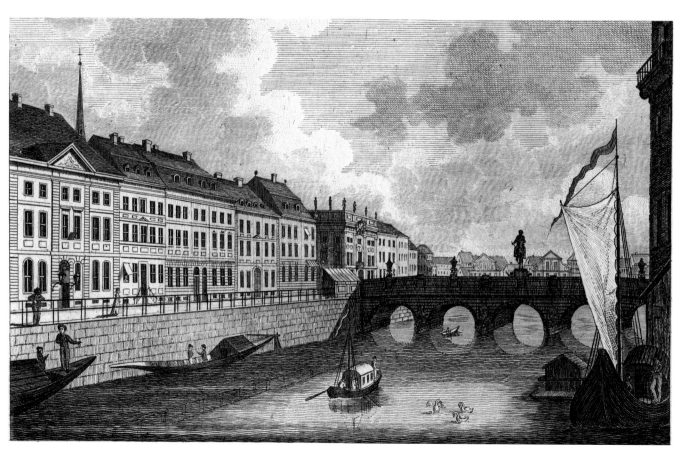

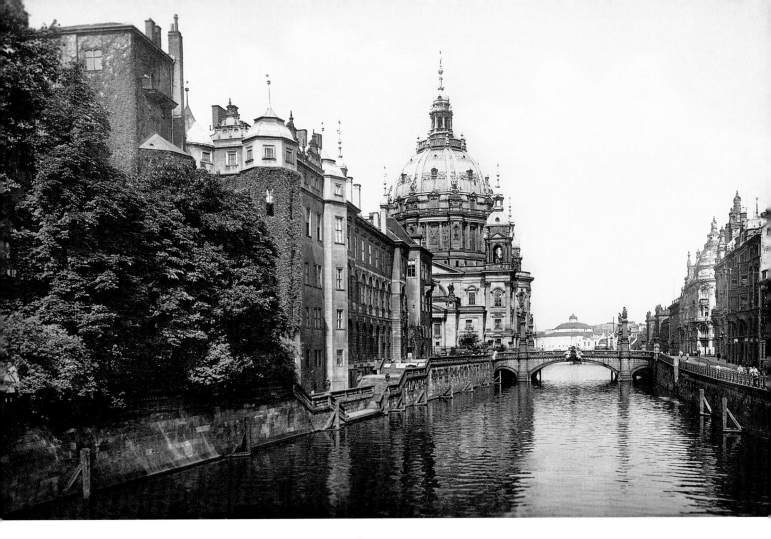

Dom und Stadtschloss,
Spreeseite um 1900
(oben) und derselbe
Standort 2008 mit dem
im Abbruch befindlichen
Palast der Republik
(rechts)

Cathedral and City Palace,
riverbank around 1900
(above) and the same scene
in the year 2008 with the
Palast der Republik being
demolished

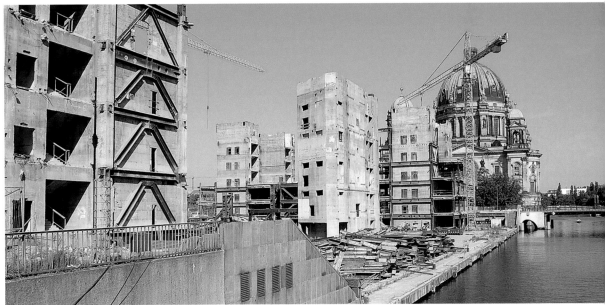

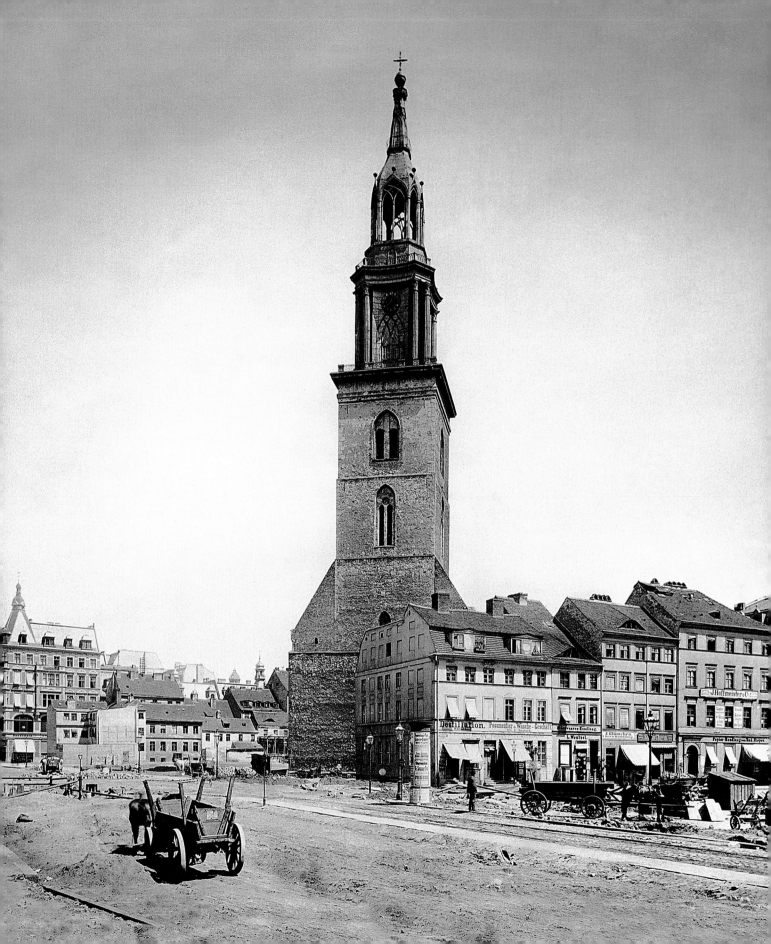

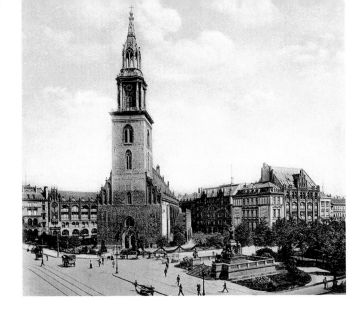

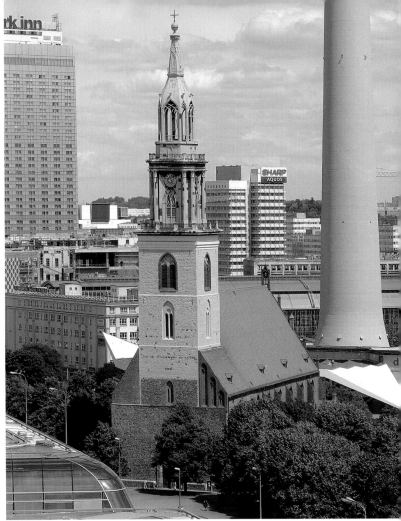

Die Marienkirche – Foto 1886 (links), um 1900 (oben) und heute (rechts) – bildete das Zentrum der um 1250 begründeten ersten mittelalterlichen Stadterweiterung Berlins und war die zweite Hauptpfarrkirche der Stadt. Ursprünglich umgeben von einer dichten Bürgerhausbebauung am Neustädter Markt steht die Marienkirche seit 1890 (Foto oben und rechts) als Solitär auf einer großen Freifläche, heute in unmittelbarer Nähe zum Fernsehturm. Die Kirche überstand den 2. Weltkrieg ohne große Schäden, sodass selbst das mächtige gotische Dachwerk erhalten blieb.

St. Mary's Church - Photo in 1886 (left), around 1900 (above) and today (right) – formed the centre of the first medieval expansion of Berlin, begun around 1250, and was the city's second main parish church. Originally surrounded by dense, middle-class housing, the Marienkirche stands alone since 1890 in a large open area – today very close to the television tower. The church survived World War II without serious damage, which means that even the mighty gothic roof was preserved.

unten: heutige Situation des ehem. Neuen Marktes
below: the scene today in the former Neuer Markt

unten: Neuer Markt, Radierung von Johann Georg Rosenberg 1785
below: Neuer Markt (New Market), etching by Johann Georg Rosenberg, 1785

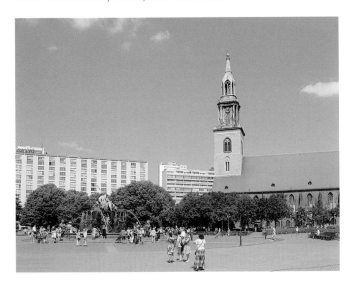

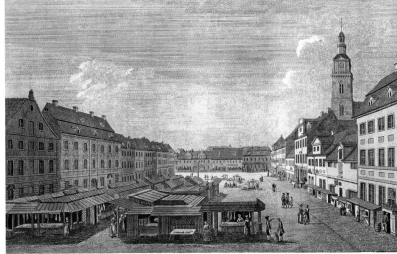

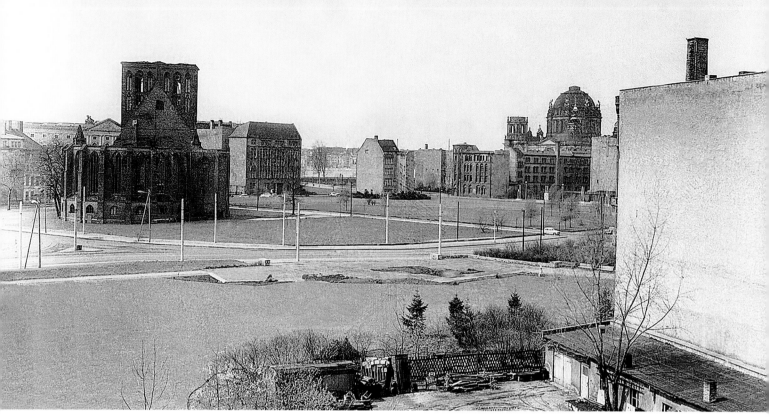

Nikolaiviertel mit Nikolaikirche 1967 (oben) und heute (unten) *Nikolai quarter and Nikolaikirche in 1967 (above) and today (below)*

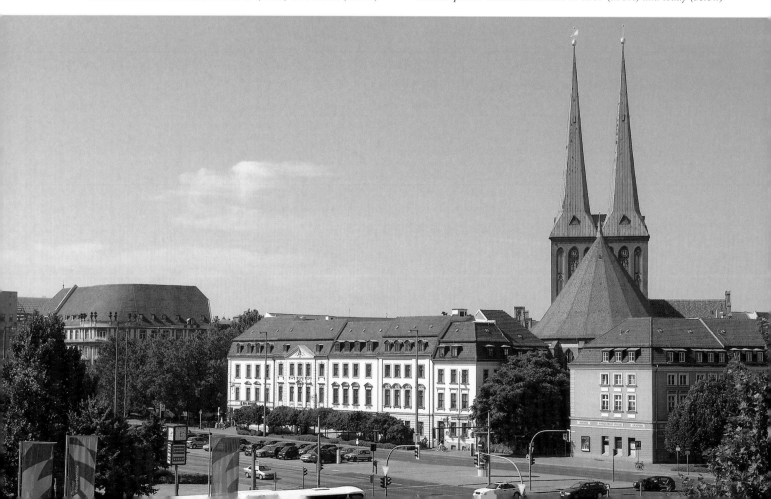

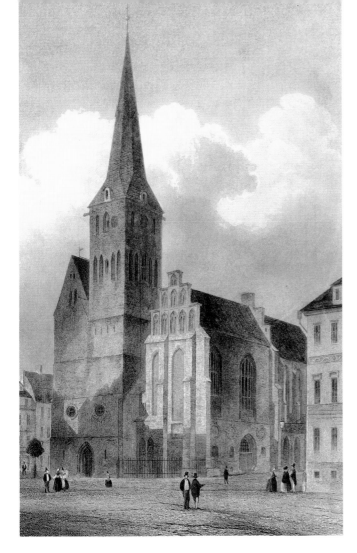

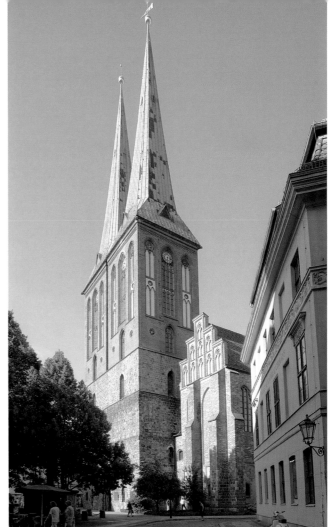

Nikolaikirche, Ansicht vor 1875 und heute
Die Kirche (Türme um 1230, dreischiffige Backsteinhalle vor 1379
– um 1460) erhielt 1876–78 unter Leitung von Hermann Blan-
kenstein den Turmaufsatz mit zwei Spitzhelmen. Der Wiederauf-
bau der 1944/45 stark beschädigten Kirche erfolgte erst 1981–87.

Nikolaikirche (St. Nicholas' Church), view before 1875 and today
The church (towers around 1230, three-aisled brick hall before 1379 to
around 1460)) was given a new tower top with two spires by Hermann
Blankenstein in 1876–78. The reconstruction of the church, which had
been severely damaged in 1944–45, was not out until 1981–87.

Blick vom Mühlendamm über die Spree zum Nikolaiviertel,
Ansicht von ca. 1890 und heute

View from the Mühlendamm to the Nikolai quarter ca. 1890 and today

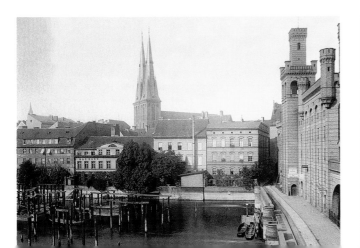

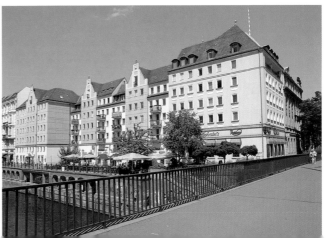

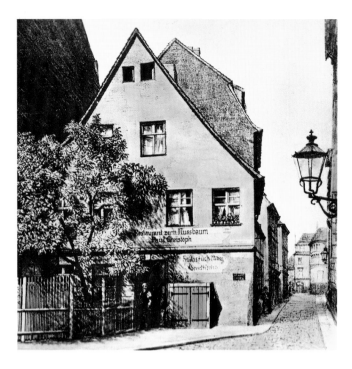

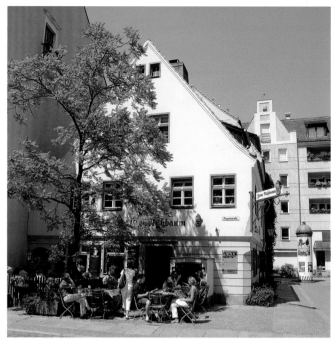

oben: Das heutige Gasthaus „Zum Nußbaum" im Nikolaiviertel (Foto rechts) ist eine Nachbildung eines Giebelhauses aus der Cöllner Fischerstraße 21 (15./16. Jh., Foto links), das 1943 zerstört worden war.

above: 'Zum Nußbaum' (The Nut Tree) in the Nikolai Quater (photo to the right) is a copy of a gable building from 21 Fischerstraße in Cölln, which was destroyed in 1943 (15th/16th century, photo to the left).

unten: Die Gerichtslaube (ehem. Berliner Rathaus) im Nikolaiviertel wiederholt die um 1270 errichtete und in der Barockzeit veränderte Gerichtslaube (Foto um 1870 unten links), die 1871 an der Stelle des heutigen Roten Rathauses abgebrochen und im Park von Schloss Babelsberg bei Potsdam gotisierend wieder aufgebaut wurde.

below: The former Berlin town hall 'Gerichtslaube' ('Courtroom Gazebo') is a copy of the gazebo built around 1270 and altered in the Baroque era, which was dismantled in 1871 (photo around 1870 left) and rebuilt in more Gothic style in the park at Schloss Babelsberg near Potsdam.

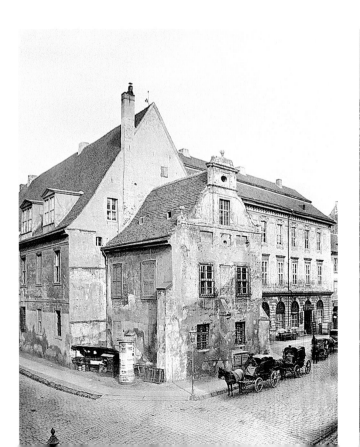

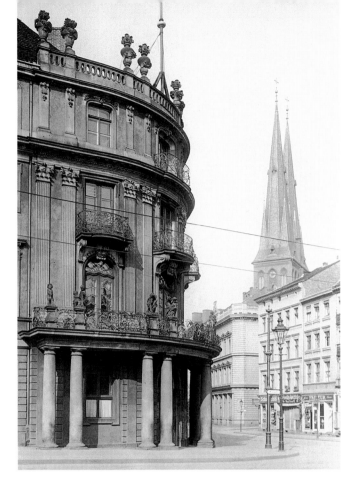

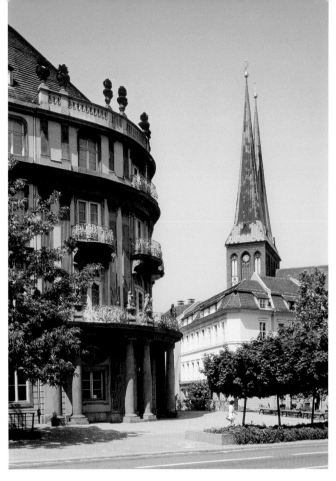

Palais Ephraim (1762–66), Nikolaiviertel/Mühlendamm um 1900 (oben und unten), 1935/36 abgebrochen, 1985–87 mit originalen Fassadenteilen neu aufgebaut (oben rechts)

Palais Ephraim (1762–66), Nikolaiviertel/Mühlendamm ca. 1900 (above left and below), demolished in 1935/36, rebuilt using original façade components in 1985–87 (above)

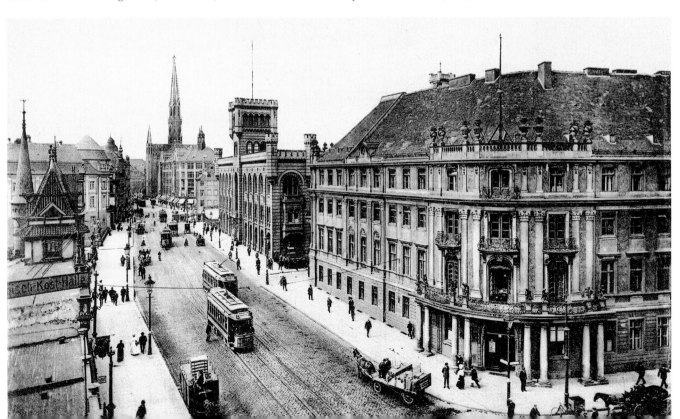

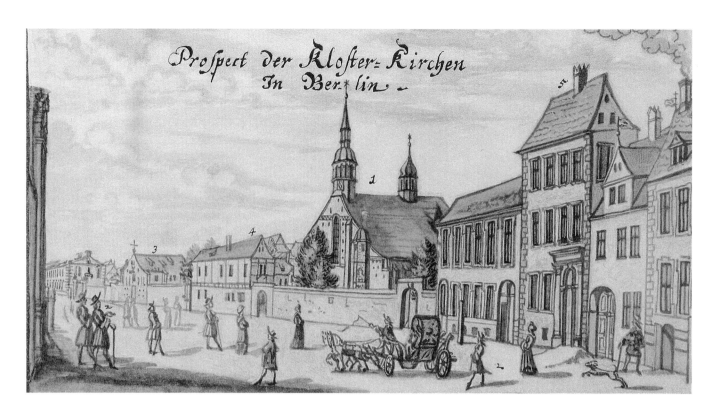

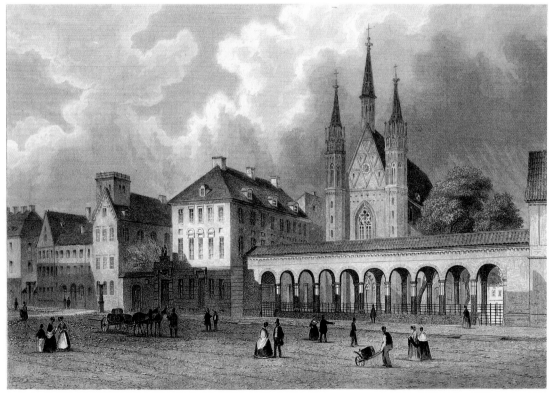

oben: Franziskaner-
kloster, Zeichnung
von Johann Stridbeck
d. J., 1690
links: Franziskaner-
kloster, Stahlstich v.
G. M. Kurz, um 1800

*above: Franciscan
monastery, drawing
by Johann Stridbeck
the Younger, 1690
left: Franciscan
monastery, etching
by G. M. Kurz,
around 1800*

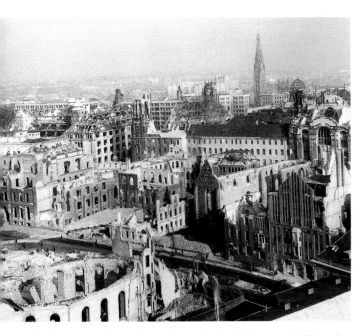

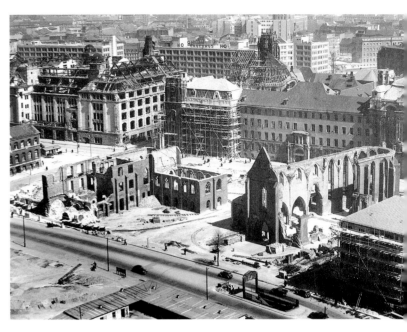

Die Ruinen der Franziskaner-Klosterkirche (Foto unten) bilden den Rest des seit 1249 in Berlin nachweisbaren und nach der Reformation 1539 aufgelösten Franziskanerklosters, dessen Klausurgebäude nach Kriegsschäden 1968 abgetragen wurden (Fotos oben).

The ruins of the 'Franziskaner-Klosterkirche' (photo below) form the remains of the Franciscan monastery in Berlin, evidence of which dates back to 1249. Its conclave building was connected to the north of the church and following war damage was cleared away in 1968 (photos above).

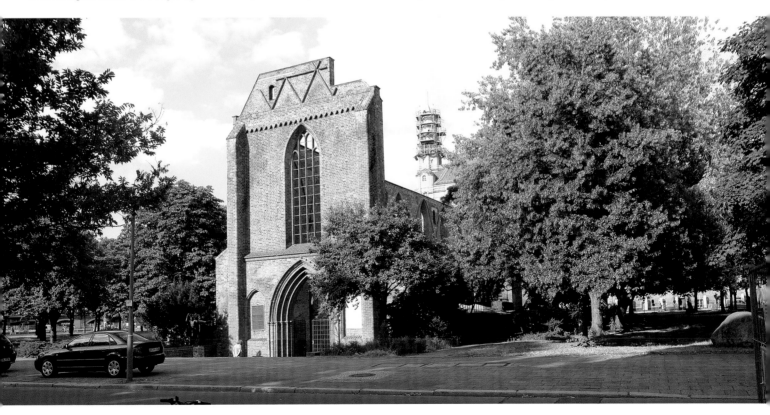

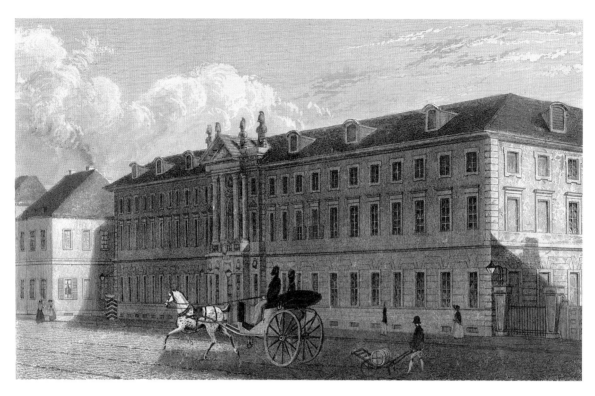

Kadettenhaus
hinter dem
ehem. Franzis-
kanerkloster
um 1785 (oben)
und heutige
Situation mit
dem Land-
gericht Berlin/
Amtsgericht
Mitte von 1896–
1904 (unten)

"Kadettenhaus"
behind the former
Franciscan
monastery
around 1785
(above) and
a current view
with the Main
Municipal Court,
1896–1904
(below)

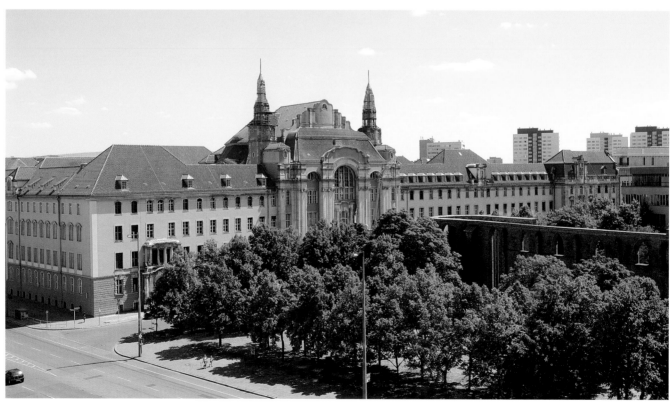

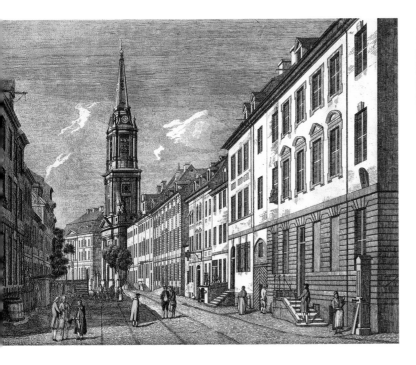

oben: Ansichten der Klosterstraße von Süden mit Parochialkirche, Kupferstich von Johann Georg Rosenberg, 1780, und Ansicht von heute. Die Parochialkirche wurde 1695 von Johann Arnold Nering begonnen, von Martin Grünberg, der 1705 die Vorhalle schuf, weitergeführt und nach Entwurf von Jean de Bodt durch Philipp Gerlach mit dem Turm 1713/14 vollendet. Die Turmobergeschosse wurden seit der Zerstörung im 2. Weltkrieg noch nicht ausgeführt.

unten: Ansichten der Klosterstraße von Norden mit der Parochialkirche, kolorierte Radierung von E. Grünewald nach Gärtner (mit „königlichem Gewerbeinstitut"), 1. Hälfte 19. Jahrhundert, und heutige Situation

above: Views down Klosterstraße from the south including the Parochialkirche. Copper etching by Johann Georg Rosenberg, 1780. The Parochialkirche was started in 1695 by Johann Arnold Nering, continued by Martin Grünberg, who created the vestibule in 1705, and completed to Jean de Bodt's design by Philipp Gerlach with the addition of the tower in 1713-14. Since being destroyed in the World War II, the tower's upper floors have not yet been rebuilt.

left and below: Views down Klosterstraße from the north including the Parochialkirche. Etching by E. Grünewald (with „königliches Gewerbeinstitut"), first half of the 19th century, and today's scene

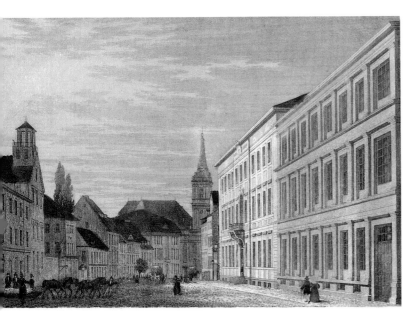

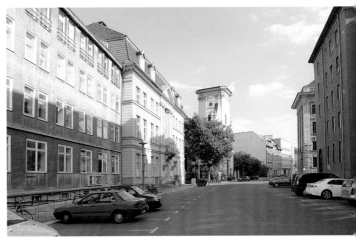

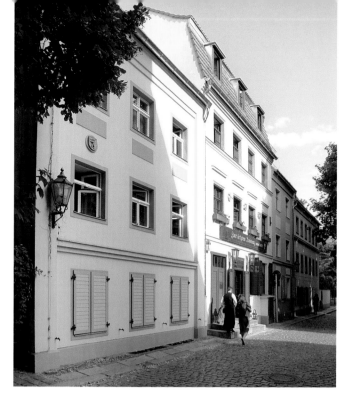

Waisenstraße (alter Straßenname: An der Stadtmauer) hinter der Parochialkirche um 1890 und heute. Hinter den Häusern stehen noch Reste der etwa 4 m hohen, aus Backsteinen und Feldsteinen erbauten Stadtmauer aus dem frühen 14. Jahrhundert.

Stadtplan (Ausschnitt) von 1847 (links) und Merian-Stich 18. Jahrhundert (Ausschnitt) mit dem Mühlendamm (rechts)

Waisenstrasse around 1890 and today. Behind the houses you can find remaining sections of the city wall from the 14th century which was 4 meters tall and made out of bricks and rubble masonry.

City Map (detail) from 1847 (left) and engraving by Merian from the 18th century (right) with the Mühlendamm

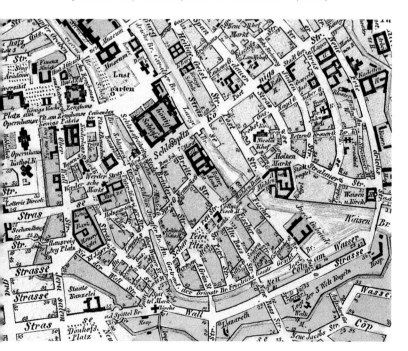

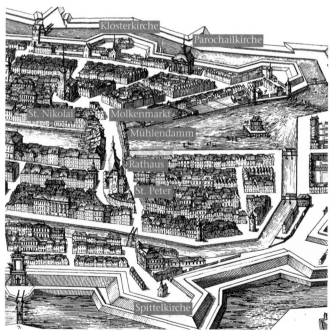

Molkenmarkt (Knotenpunkt dreier Handelsrouten und ältester Markt Berlins) um 1900 (oben und links) und heute (unten), im Hintergrund das Alte Stadthaus von 1902–11 mit 80 m hohem Turm

Molkenmarkt (intersection of three trade routes and the oldest market of Berlin) around 1900 (above and left) and today (below) with the Alte Stadthaus, built from 1902–11, with a 80-meter high tower

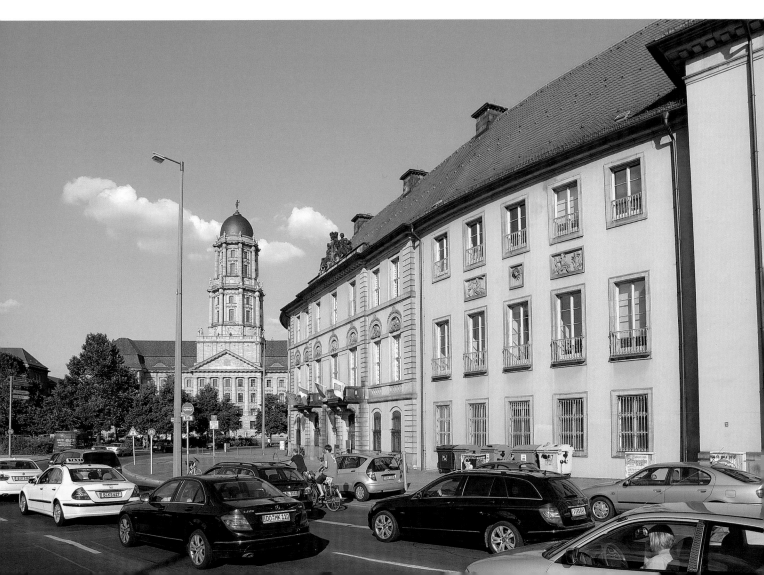

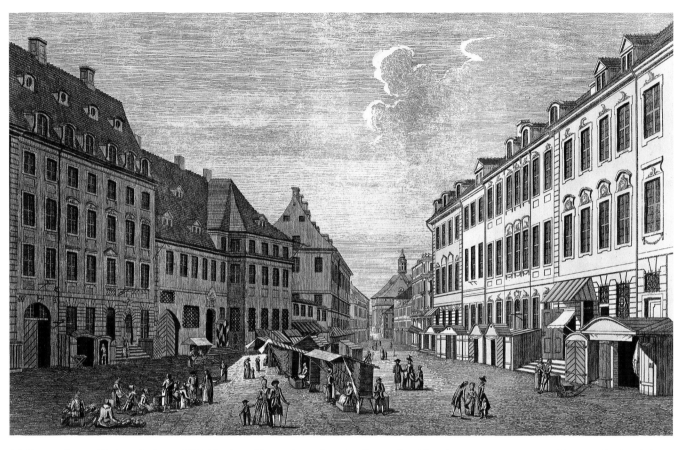

Molkenmarkt mit Blick zu St. Peter 1785 (oben) und heute (unten) *Molkenmarkt with a view to St. Peter in 1785 (above) and today (below)*

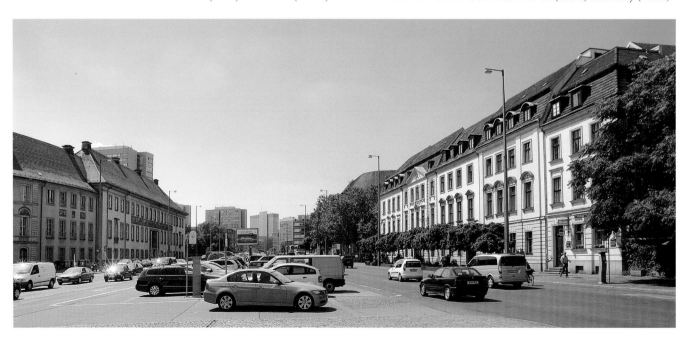

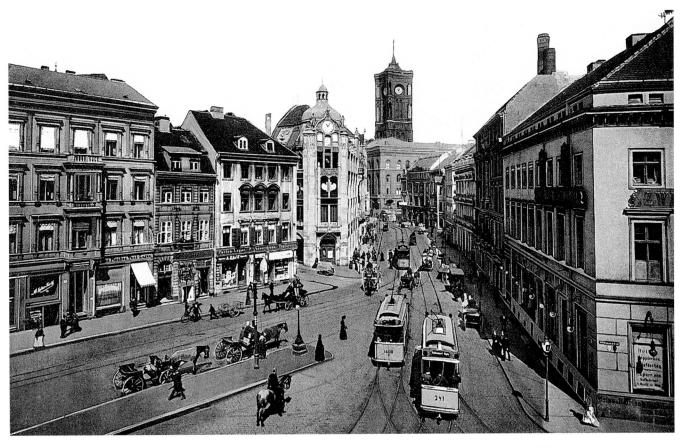

Molkenmarkt und Rotes Rathaus um 1900 (oben) und heute (unten) *Molkenmarkt and 'Rotes Rathaus' around 1900 (above) and today (below)*

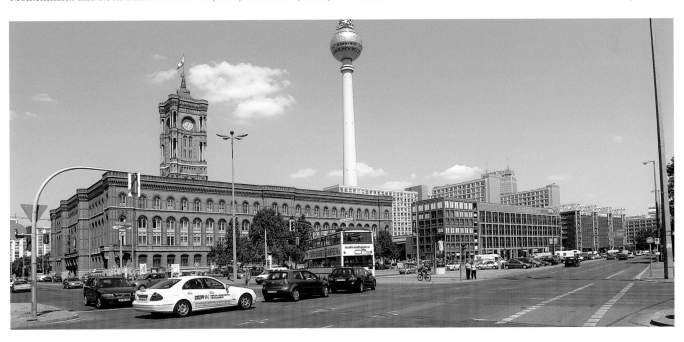

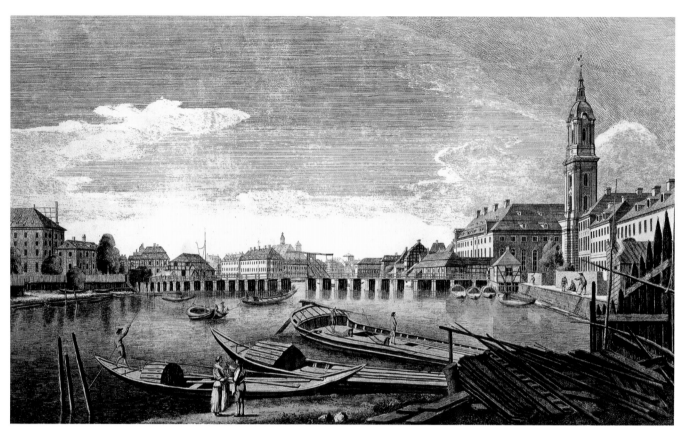

Blick von der Stelle der heutigen Janowitzbrücke auf die Waisenbrücke und die Waisenhauskirche (rechts) 1785 und um 1820
View from the location of the modern Janowitzbrücke toward the Waisenbrücke and the Waisenhauskirche (right) in 1785 and around 1820

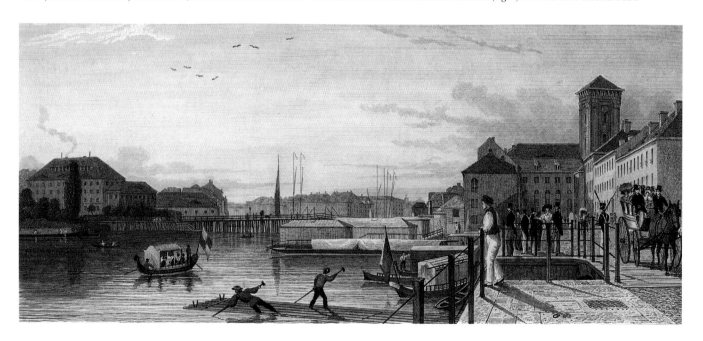

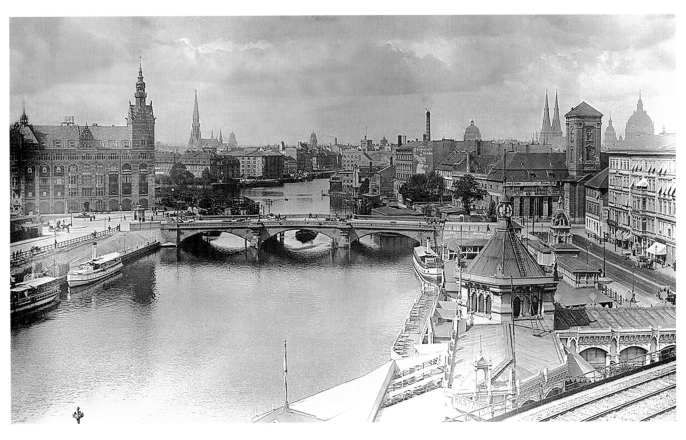

Blick von der Janowitzbrücke auf die heute zerstörte Waisenbrücke und die ehemalige Waisenhauskirche (rechts) um 1900 und heute
View from the Janowitzbrücke (Janowitz bridge) toward the now destroyed Waisenbrücke and the former Waisenhauskirche (right) around 1900 and today

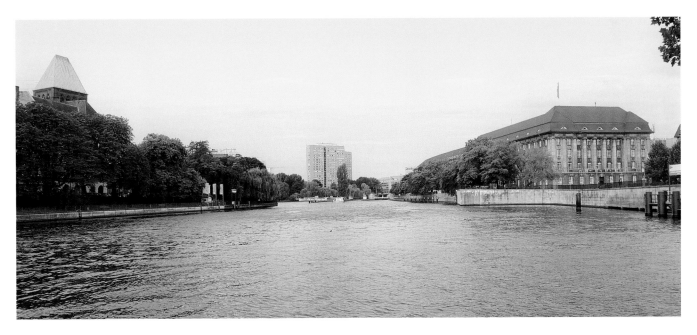

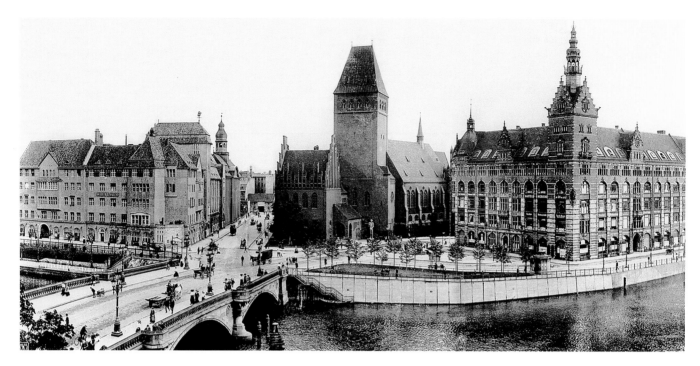

Märkisches Museum um 1910 mit Waisenbrücke (oben) und heute (unten)
Seite 47: Blick auf die Spree vom Mühlendamm um 1900 und heute
Märkisches Museum around 1910 with the Waisenbrücke (bridge) (above) and today (below)
page 47: View from the Mühlendamm toward the river Spree around 1900 and today

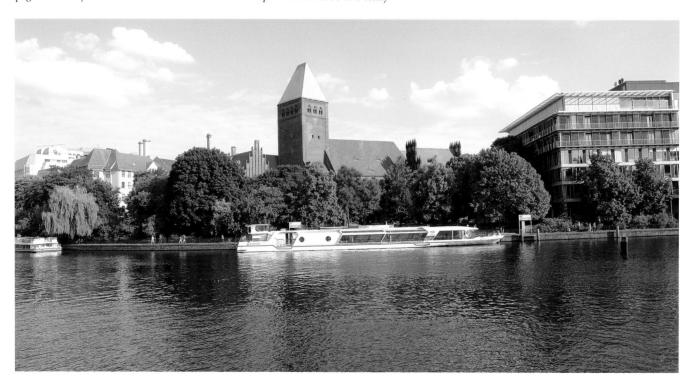

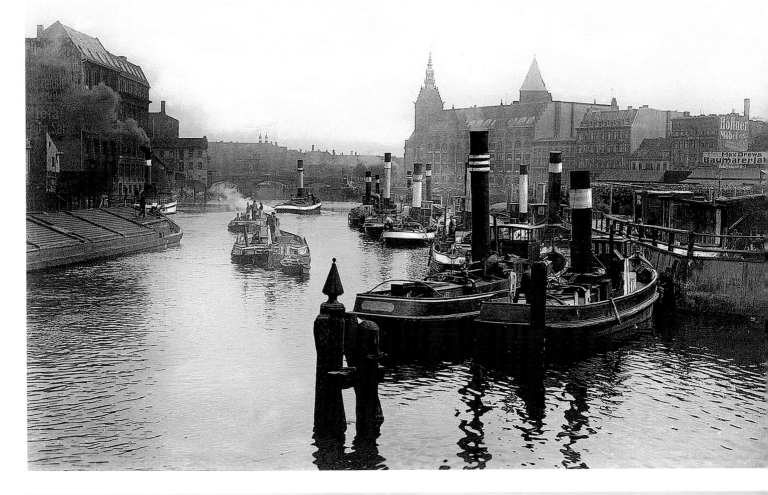

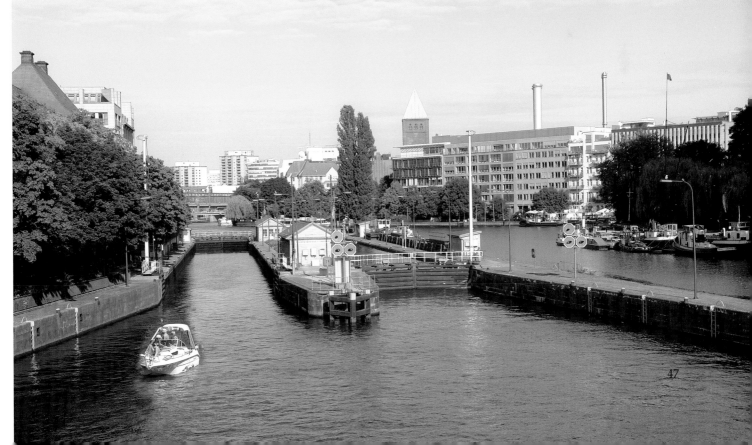

47

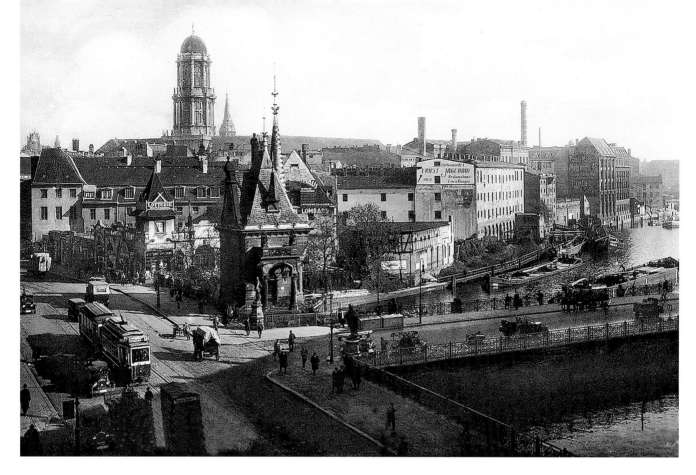

Mühlendamm mit Blick zum Stadthaus um 1920. Das Bild zeigt den Zustand der durch Hermann Blankenstein 1888–92 errichteten ersten Mühlendammschleuse, die ab 1936 ebenso wie z. B. das Ephraim-Palais einem Brücken- und Schleusenneubau weichen musste. *Mühlendamm with a view of the Stadthaus around 1920. The picture shows the condition of the first Mühlendamm lock constructed by Hermann Blankenstein 1888–92, which also gave way to the construction of a bridge and lock after 1936, just like the Ephraim-Palais.*

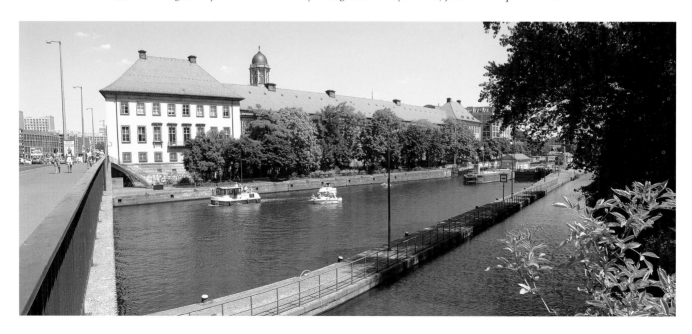

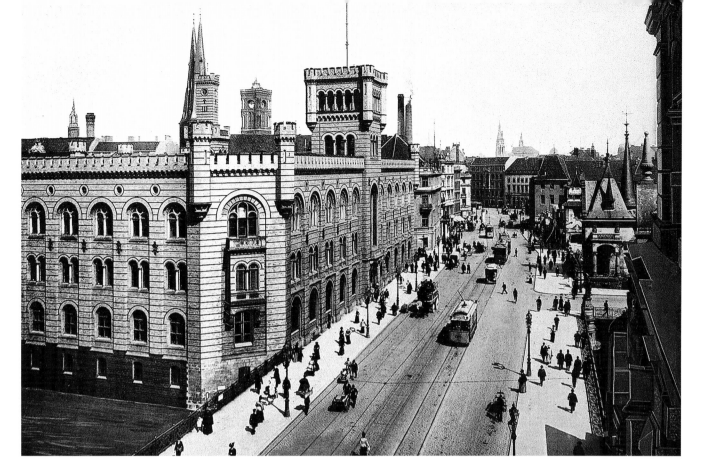

Mühlendamm und Mühlenbau um 1900 und heute. Der Mühlendamm markiert den alten Übergang über die Spree. Der Name stammt von den Wassermühlen, die einst hier arbeiteten. Der Mühlenbau wurde im 2. Weltkrieg zerstört.
Mühlendamm and Mühlenbau around 1900 and today. The Mühlendamm marks the old crossing over the Spree. The name comes from the watermills that once operated here. The watermills were destroyed in the World War II.

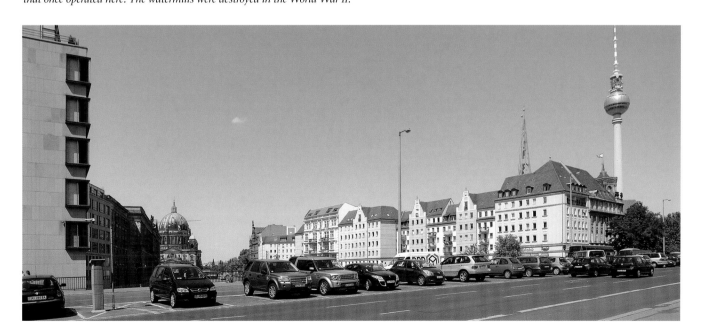

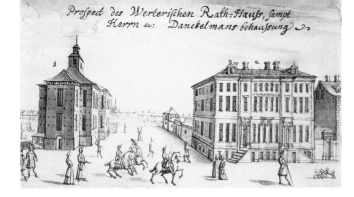

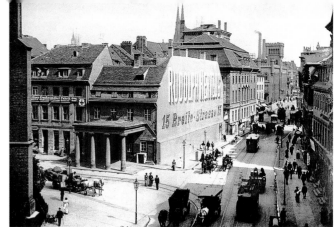

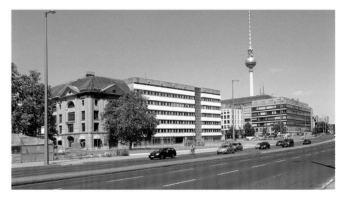

Cöllner Fischmarkt (heute Mühlendamm) mit dem Cöllnischen Rathaus, Zeichnung von Johann Stridbeck d. J. 1690 (oben), Kupferstich von Johann Georg Rosenberg 1785 (Mitte) und heute (unten)
Cölln fish market (today's name: Mühlendamm) mit the town hall. Drawing by Johann Stridbeck the Younger 1690 and copper etching by Johann Georg Rosenberg, 1785 (above) and today's situation (below)

Blick vom Petriplatz zum Mühlendamm um 1900 und heute
View from the Petriplatz to the Mühlendamm around 1900 and today

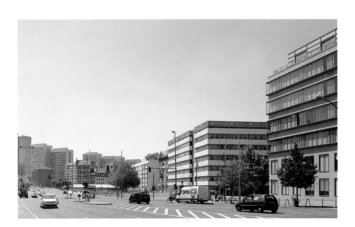

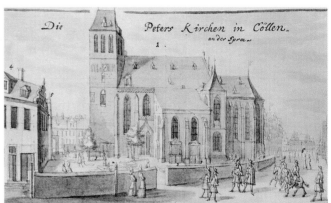

rechts: Peterskirche, Zeichnung von Johann Stridbeck d. J. 1690, und heutige Situation (unten). Die Kirche (14. Jh., 1846–53 erneuert) wurde nach schweren Kriegsschäden 1960 abgetragen.
right: Peterskirche, drawing by Johann Stridbeck, 1690, and today's scene. The ruins of the church were cleared away in 1960.

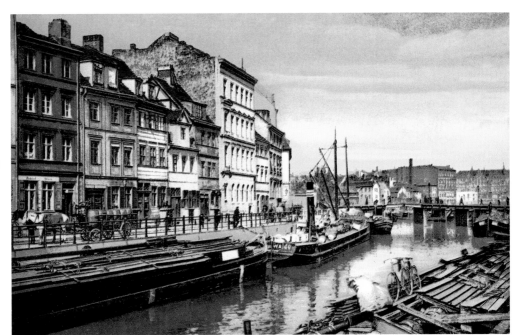

Märkisches Ufer – Postkarte um 1910 mit linker Uferbebauung (oben) und aktuelles Foto mit rechter Uferbebauung (alter Straßenname: Neu-Cölln zu Wasser, unten) – seit 1680 angelegt, Häuser 18.–20. Jahrhundert– Nr. 16 um 1790, Nr. 18 um 1730, Nr. 10 (Ermeler-Haus) 1760–63 bzw. 1804 (Fassade) (transloziertes bzw. rekonstruiertes Gebäude, ursprünglich: Breite Straße 11)

Märkisches Ufer (embankment) – postcard ca. 1910 (above) and new photo (below) – laid out since 1680, houses built 18th–20th century, e. g. no. 16 ca. 1790, no. 18 ca. 1730 and no. 10 (Ermeler Haus) 1760–63/1804 (façade), a relocated/ reconstructed building, originally at 11 Breite Straße)

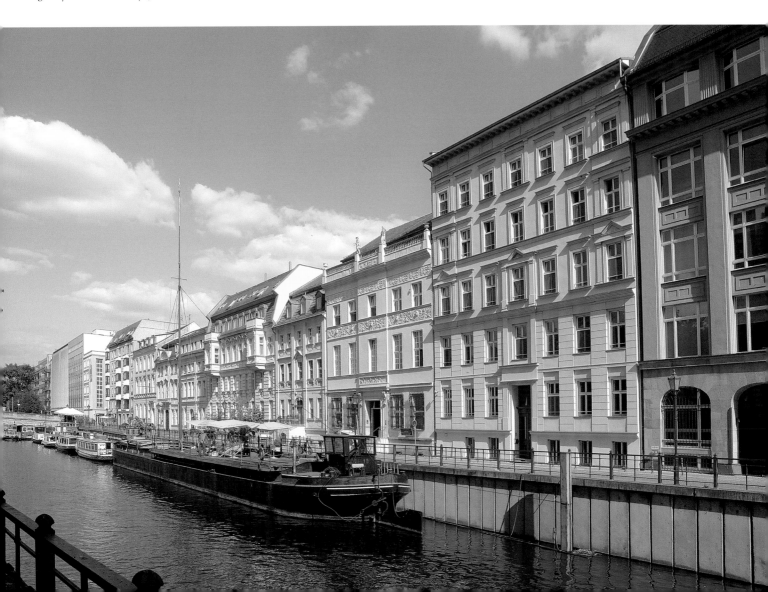

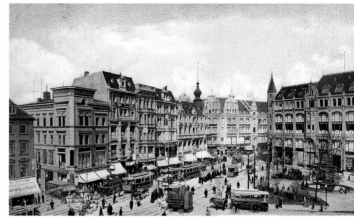

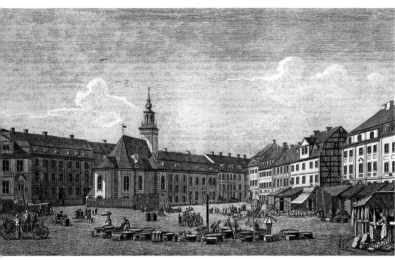

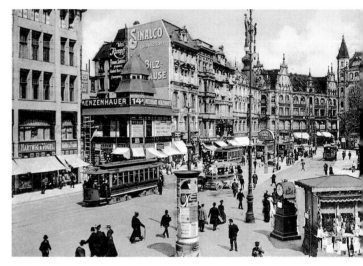

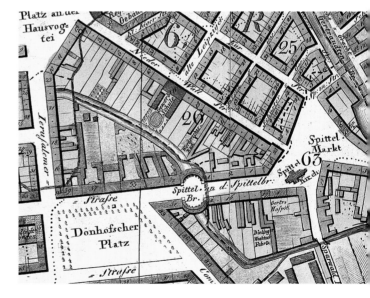

oben: Gertraudenhospital, Zeichnung von Johann Stridbeck d. J., 1690, und Zustand 1785. Die Kirche ("Spittelkirche") des Gertraudenhospitals wurde 1405–11 erbaut und 1881 abgebrochen. Das Hospital lag außerhalb der Stadt vor dem gleichnamigen Tor (Gertraudisches Tor) in Cölln am heutigen Spittelmarkt.
oben rechts: Spittelmarkt um 1890 und um 1900
rechts: Kartenausschnitt von 1846

above: Gertrude Hospital. Drawing by Johann Stridbeck the Younger, 1690, and situation in 1690. The hospital's church ('Spittelkirche') was built in 1405–11 and demolished in 1881. The hospital stood outside the city, just beyond the city gate of the same name (Gertrautisches Tor) in Cölln, on what is now Spittelmarkt.
above right: Spittelmarkt around 1890 and around 1900
right: Detail of a map, 1846

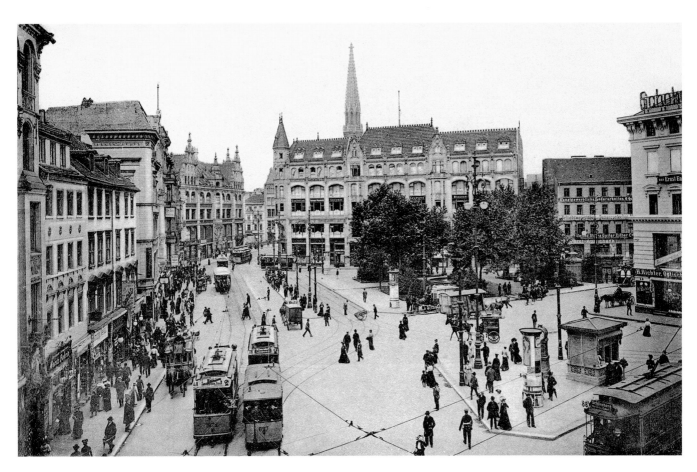

Spittelmarkt um 1900 und heute. Der am östlichen Ende der Leipziger Straße gelegene Platz zählt zu den ältesten Anlagen dieser Art in Berlin. Seine unregelmäßige Gestalt zeugt von seiner einstigen Aufgabe als Bastion in der Stadtbefestigung. Seinen Namen verdankt er dem Getrauden-hospital (Spittel = Spital), in dem vor allem alleinstehende arme Frauen Zuflucht fanden. Nach der Zerstörung im 2. Weltkrieg wurde der Platzcharakter aufgegeben.

Spittelmarkt around 1900 an today. The square, which is located at the eastern end of Leipziger Straße, is among the oldes squares of this type in Berlin. Its irregular form testifies to its one-time function as a bastion in the city fortfications. It owes its name to the Getraudenhospital (Spittel = Spital), which primarily provided refuge for single, poor women. After being destroyed in the World War II, the square was not rebuilt as such.

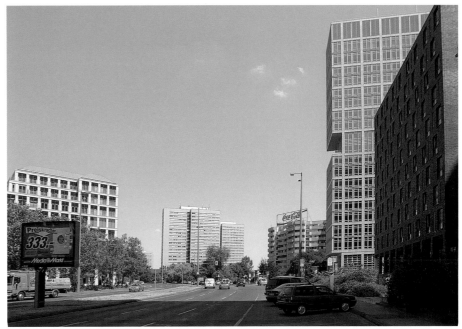

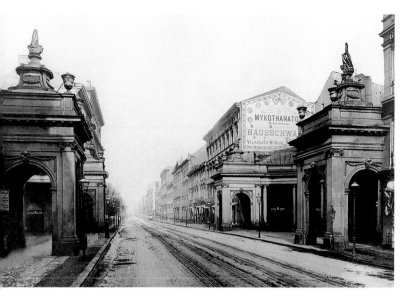

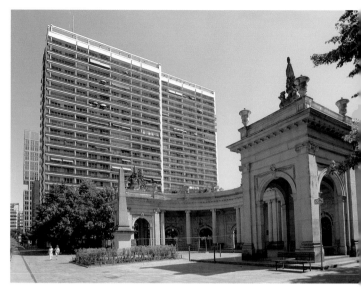

Spittelkolonnaden um 1900 (oben) – 1776 von Carl von Gontard als Schmuck über der Brücke, die über den Festungsgraben führte, zwischen Leipziger Straße und Spittelmarkt errichtet – und heute (Rekonstruktion von 1979, oben rechts)
Spittelkolonnaden around 1900 (top), built in 1776 by Carl Philipp Christian von Gontard as decoration above the bridge that led over the moat, between Leipziger Straße and Spittelmarkt, and today (rebuilt in 1979, top right)

unten: Brüderstraße, Zeichnung von Johann Stridbeck d. J. 1690 und heute. 1297 siedelten sich die Dominikaner an der Stelle des späteren Schlossplatzes an. Die zum Kloster führende Straße erhielt den Namen „Brüderstraße", die im 16. Jahrhundert ebenso wie die Breite Straße zur Wohnstraße für adlige Hofbedienstete wurde. Die Zeichnung zeigt den südlichen Teil der Straße mit Blick zur Petrikirche im Hintergrund. Das fünfte Gebäude von rechts erwarb 1787 der Buchhändler Nicolai. Das Barockgebäude überlebte den 2. Weltkrieg.

above: Brüderstraße, Drawing by Johann Stridbeck the Younger 1690 (left) and today (right). In 1297, the Dominican monks settled on what was later to be Schlossplatz (Palace Square). The road leading to the monastery was given the name 'Brüderstraße' (Brothers Street), becoming in the 16th century, like 'Breite Strasse' (Broad Street), a residential road for aristocratic courtiers. The illustration shows the southern part of the street, looking towards St. Peter's Church in the background. The Baroque building fifth from the right was purchased in 1787 by the book dealer Nicolai and survived the World War II (s. photo).

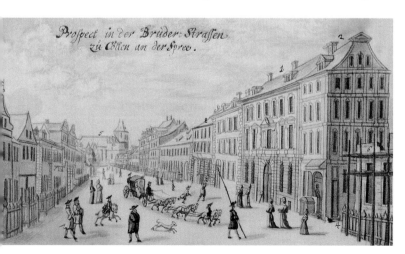

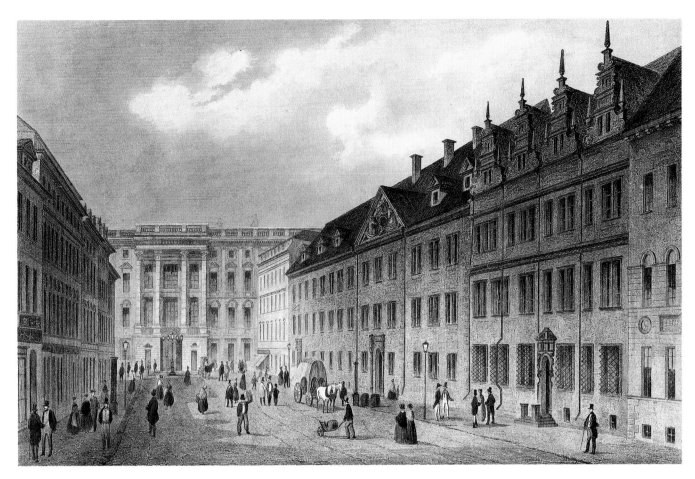

Breite Straße mit Blick zum ehem. Stadtschloss, um 1800 und heute. Zu sehen ist rechts das einzige erhaltene Renaissancegebäude, das Ribbeck-Haus, Breite Straße 35. Das 1624 für den kurfürstlichen Kammerherrn Hans Georg von Ribbeck errichtete Gebäude wurde nach Kriegsschäden in der ursprünglichen Form rekonstruiert.

Breite Straße with the view to the former city palace. On the right, one can see the only remaining Renaissance building to have been preserved – the 'Ribbeck Haus' at 35 Breite Straße, built in 1624 for the electoral chamberlain Hans Georg von Ribbeck. In 1959 after being damaged in the World War II the façade was rebuilt in the original style.

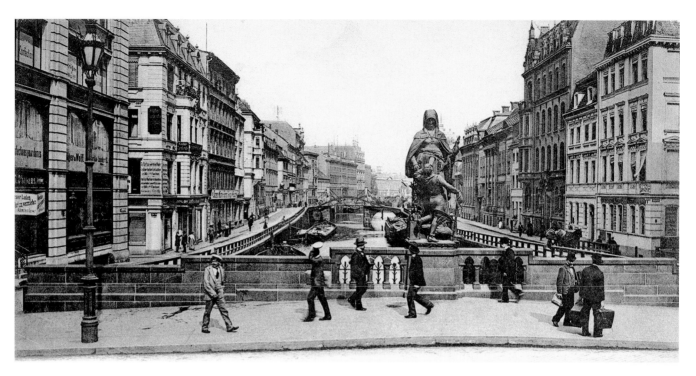

Gertrudenbrücke mit der Gertrudenfigur um 1900 und heute *Gertrudenbrücke with the statue of Gertrude around 1900 and today*

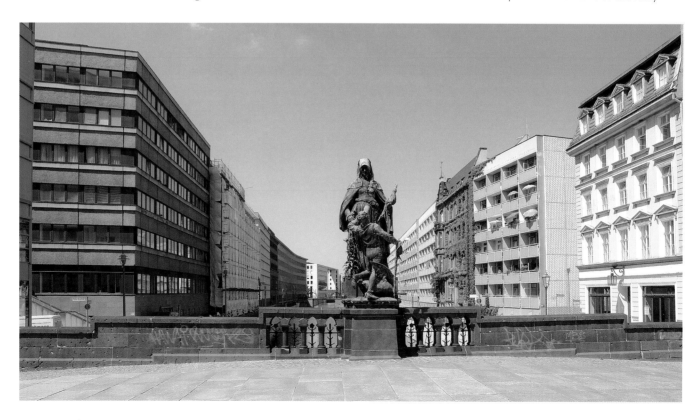

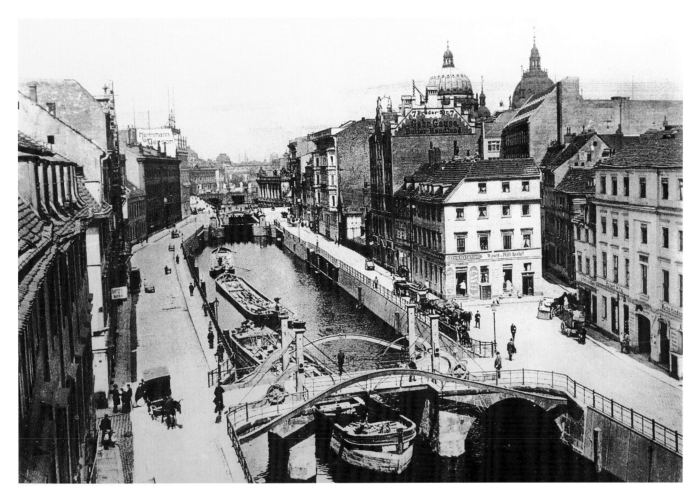

Spreekanal mit Jungfernbrücke und der Uferbebauung der ehemaligen Straße „An der Schleuse" um 1900 (oben) und heute (unten)

Spreekanal with Jungfernbrücke and the houses along the former street „An der Schleuse" around 1900 (above) and today (below)

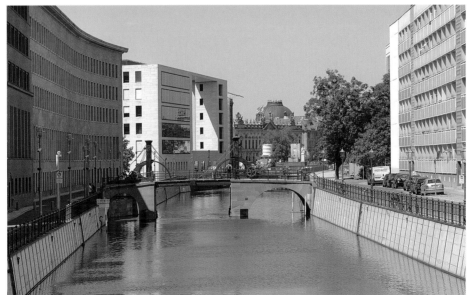

Stadtschloss

Das monumentale Schloss war bis 1918 die Residenz der hohenzollernschen Kurfürsten, Könige und Kaiser. Ihren Ursprung hat die Anlage in der von 1443 bis 1451 errichteten Burg, die unter Joachim II. ab 1538 zu einem prächtigen Renaissanceschloss und von 1698 bis 1716 unter Leitung von Andreas Schlüter und Johann Friedrich Eosander v. Göthe ihre einheitliche Form im Stil des Barock erhielt. Das Stadtschloss besaß eine Ausdehnung von fast 200 m Länge, 117 m Breite und war 30 m hoch. Den Westflügel krönte eine Kuppel von beinahe 70 m Höhe.

1945 schwer beschädigt, wurde das Schloss 1950/51 gesprengt. Ideologische Gründe waren dafür ausschlaggebend: Nicht ein monarchisch-herrschaftlicher Monumentalbau, sondern ein Demonstrationsplatz für die Massen sollte die Stadtmitte der sozialistischen Hauptstadt der DDR einnehmen. Seit 2013 wird das Stadtschloss mit seinen Barockfassaden rekonstruiert. Die Maßnahmen sind 2019 abgeschlossen. Auf dem Areal des früheren Ostflügels erstreckte sich bis 2008 der „Palast der Republik", der Repräsentationsbau der DDR (1973–76 unter Leitung von Ehrhardt Gißke, Heinz Graffunder und Karl-Ernst Swora erbaut). Der 84 m x 180 m große und 32 bzw. 25 m hohe Baukörper nahm die Volkskammer mit Plenarsaal für 500 Abgeordnete und Restaurants sowie einen Saal für 4700 Besucher auf.

Das 1964–67 gegenüber erbaute zehnstöckige DDR-Außenministerium wurde 1995 abgebrochen.

Häuserzeile entlang der „Schlossfreiheit" vor dem Stadtschloss um 1880
Houses at the „Schlossfreiheit" in front of the City Palace around 1880

City Palace

Until 1918, this monumental palace was the residence of the Hohenzollern electors, kings and Kaisers. The complex had its origins in the castle built from 1443 to 1451, which was converted from 1538 under Joachim II into a magnificent Renaissance palace. From 1698 to 1716, under the direction of Andreas Schlüter and Johann Friedrich Eosander v. Göthe, it was given its uniform Baroque appearance. The Stadtschloss, or City Palace, was almost 200 metres long, 117 metres wide and 30 metres high. On the west wing sat a dome of almost 70 metres in height.

After being severely damaged in 1945, the palace was blown up in 1950–51 and the remains torn down. This wilful act of destruction was mainly motivated by ideological reasons, as the communist rulers of Eastern Germany did not wish to have a monarchial palace in the middle of their capital, but instead a square for huge mass parades by the "proletariat." The palace is rebuilt from 2013 to 2019.

Along the banks of the Spree river where the east wing used to stand is today the so-called Palace of the Republic (pictured below), an ostentatious modern building built under the communist regime (1973–76 by Ehrhardt Gisske, Heinz Graffunder and Karl-Ernst Swora). Measuring 84 meters x 180 meters in area and rising up to between 32 and 25 meters high, the building housed a 500-seat assembly hall for the People's Congress as well as several restaurants and a hall for 4,700 visitors.

The ten-story foreign ministry building of the GDR (built from 1964–67), which used to stand across from it, has been torn down in 1995.

Die Häuser entlang der „Schlossfreiheit" ersetzte man 1897 durch das Nationldenkmal für Kaiser Wilhelm I. von Reinhold Begas.
The houses at the „Schlossfreiheit" were replaced for the Emperor William I National Memorial in 1897 by Reinhold Begas.

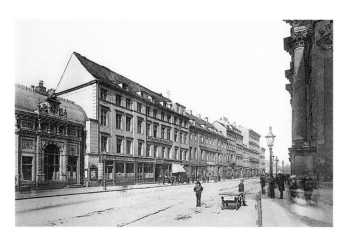

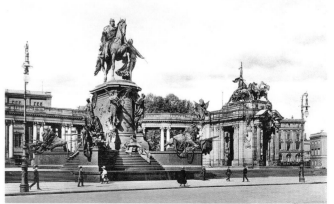

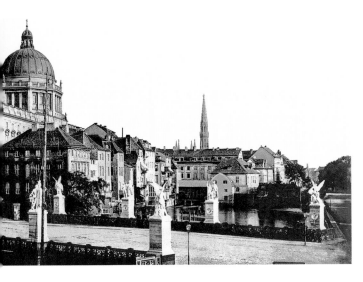

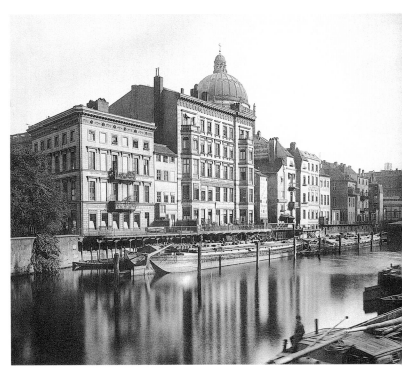

Stadtschloss mit Schlossbrücke und Häuserzeile an der „Schlossfreiheit"
um 1860 (oben), Häuser an der „Schlossfreiheit" um 1880 (rechts) und
Stadtschloss nach Abbruch der Häuser um 1900 (unten)
*City Palace with the Schlossbrücke and the houses at the „Schlossfreiheit"
around 1860 (above), the houses at the „Schlossfreiheit" around 1880 (right)
and the City Palace after the houses were demolished around 1900 (below)*

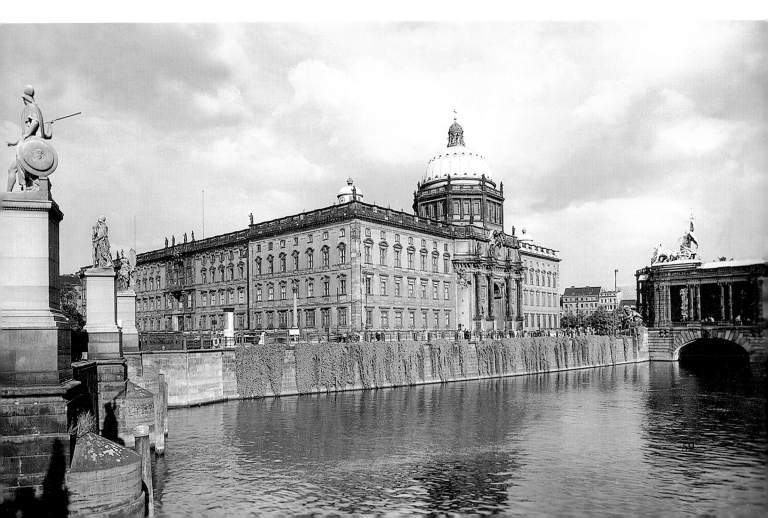

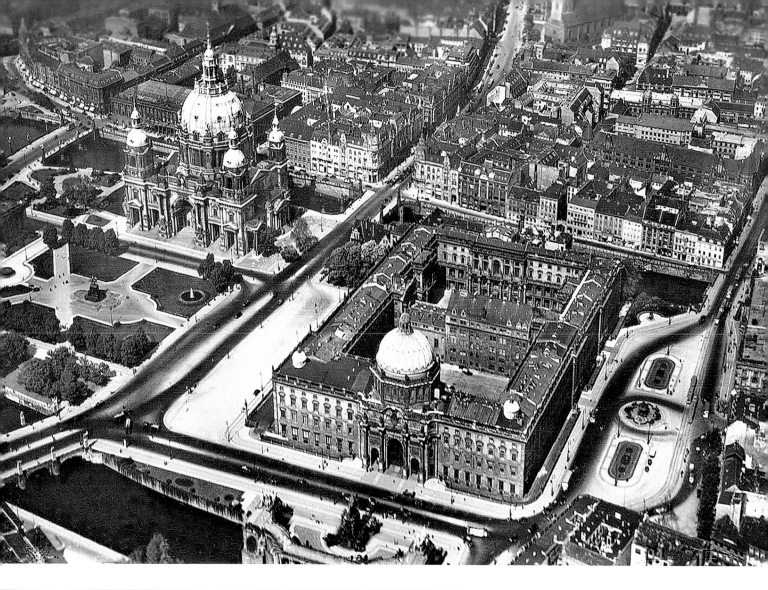

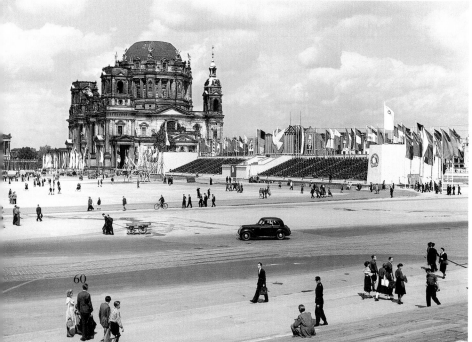

oben: Blick um 1930 über den Dom und das Stadtschloss

above: View ca. 1930 via the cathedral and the City Palace

links: Blick um 1955 zum Dom nach Sprengung des Stadt-schlosses

left: Cathedral around 1955 after the demolition of the City Palace

Seite 61 oben: Blick um 1946 über den kriegsbeschädigten Dom und das Stadtschloss

page 61 above: View ca. 1945 via the cathedral and the City Palace after being damaged in the War

Seite 61 unten: Blick 1995 über den Dom, Palast der Republi und ehem. DDR-Außenministerium

page 61 below: View 1995 via the cathedral, the Palast der Republik and foreign ministry building of the GDR

60

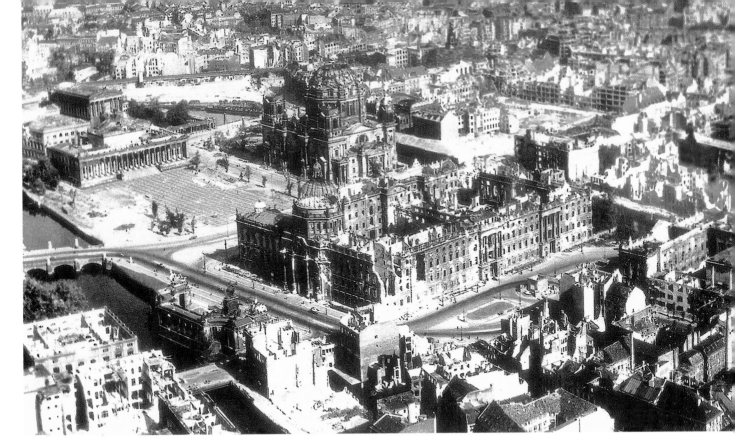
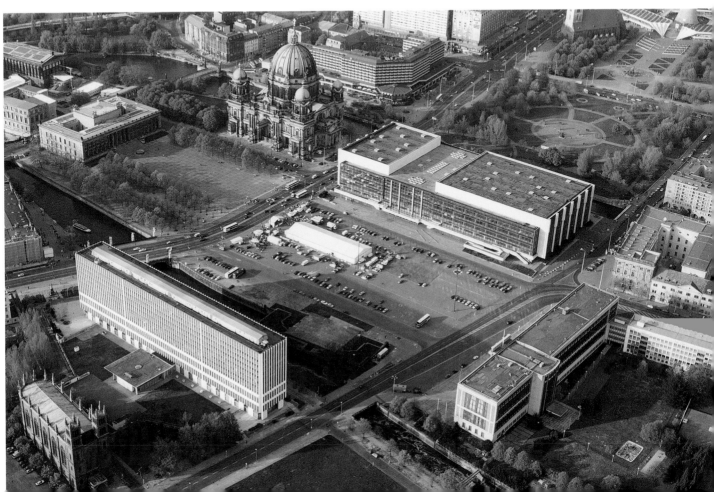

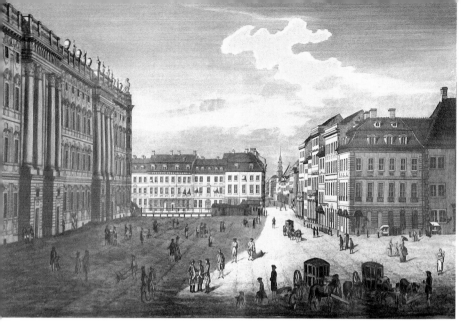

Seite 63: Palast der Republik von Heinz Graffunder und Karl-Ernst Swora, 1973–76, Abriss 2006–09 (Fotos unten) und Schlossrekonstruktion 2016/17 (unten rechts)

page 63: 'Palast der Republik' by Heinz Graffunder and Karl-Ernst Swora, 1973–76, demolition 2006–2009 (photos below) and new City Palace 2016/17 (photo below right)

links: Schlossplatz nach Osten 1781 (Kupferstich von Johann Georg Rosenberg) mit der Schlossfassade links und Blick zum Turm des alten Rathauses

left: Schlossplatz to the east in 1781, copper etching by Johann Georg Rosenberg, withe the façade of the City Palace to the left and view toward the tower of the old town hall

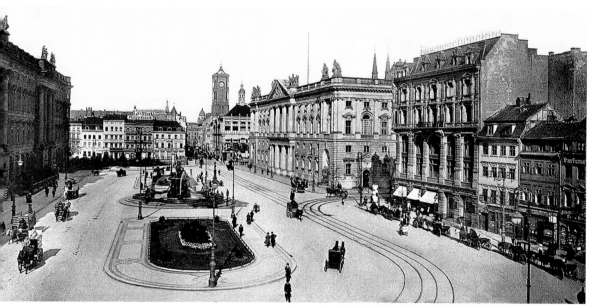

Schlossplatz nach Osten um 1900 mit der Hauptfassade des ehemaligen Königlichen Marstalls wurde 1897–1902 von Ernst von Ihne (1848–1917) im Stil des Stadtschlosses errichtet; im Hintergrund der Turm des Roten Rathauses

Schlossplatz to the east around 1900, Neuer Marstall (New Stables), originally located opposite the City Palace, built in 1896–1901 by Ernst von Ihne in Neo-Baroque form, reflecting the style of the City Palace, in the background the tower of the Rotes Rathaus („Red Town Hall")

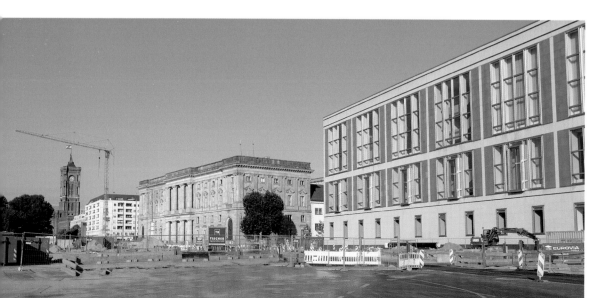

Schlossplatz nach Osten heute mit dem ehem. Staatsratsgebäude der DDR (1962–64) von Roland Korn und Hans-Erich Bogatzky

Schlossplatz to the east today with the GDR's former state council building, built 1962–64, designed by Roland Korn and Hans-Erich Bogatzky

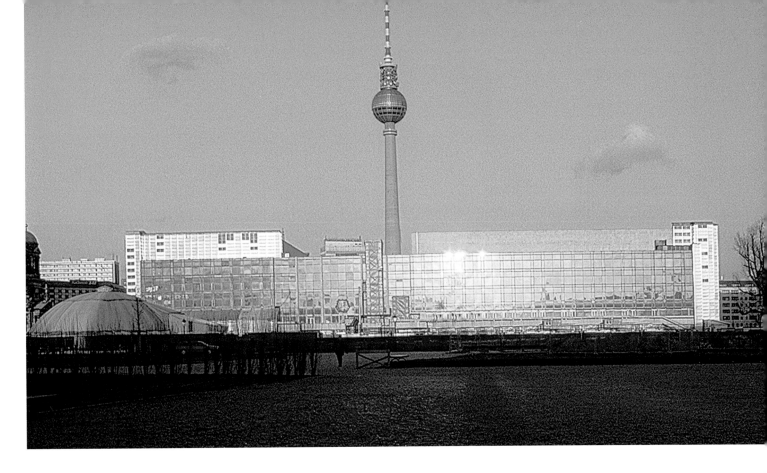

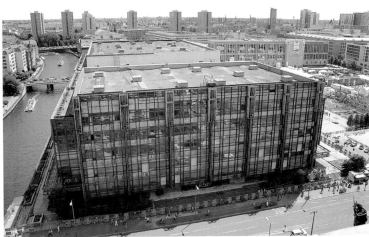

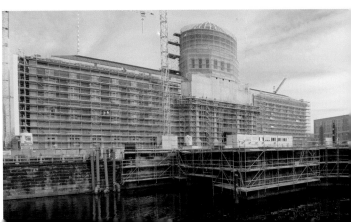

Berliner Dom und Museumsinsel

Der Berliner Dom – nach Entwürfen von Julius Raschdorff 1894–1905 als imposantes neobarockes Bauwerk mit reicher Innenausstattung errichtet – orientiert sich in seinen Architekturformen am Petersdom in Rom. Seine Bedeutung spiegelt sich anhand seiner exponierten Lage am Lustgarten zwischen dem Alten Museum und dem ehem. Stadtschloss und seinen Funktionen als Oberpfarr- und Domkirche sowie als Grabkirche der Hohenzollern wider. Der schlichte Vorgängerbau, der nach Plänen von Knobelsdorff durch Johann Boumann 1747–50 errichtet und 1817–22 durch Schinkel klassizistisch umgestaltet worden war, musste auf Druck Kaiser Wilhelms II. dem Repräsentationsbau „als Hauptkirche des preußischen Protestantismus in Berlin" weichen. Nach Kriegsschäden wurden die Kuppeln vereinfacht wiederaufgebaut.

Der nördliche Teil der Spreeinsel im Zentrum Berlins besteht aus einem einzigartigen Ensemble von fünf bedeutenden Museumsbauten, die zum Weltkulturerbe gehören. Zunächst entstand zwischen 1825 und 1830 das Alte Museum von Schinkel, ein Hauptwerk des Klassizismus, als der drittälteste Museumsbau Deutschlands – nach dem Fridericianum in Kassel und der Münchner Glyptothek. Die Entwicklung zur Museumsinsel begann 1830 mit der Eröffnung des Alten Museums von Schinkel und setzte sich mit dem Neuen Museum 1843–55 von Friedrich August Stüler fort, der auch die Alte Nationalgalerie entwarf (1866–76 von Johann Heinrich Strack ausgeführt). Das Bodemuseum entstand 1897–1904. 1909–30 folgte nach Entwürfen von Alfred Messel unter Ludwig Hoffmann der Bau des Pergamonmuseums als erstes Architekturmuseum der Welt. Um den Anforderungen einer modernen Museumslandschaft zu entsprechen, werden die Gebäude nach einem Masterplan des Londoner Architekten David Chipperfield gegenwärtig unterirdisch miteinander verbunden und um einen Eingangsneubau erweitert.

Berliner Dom and Museum Island

Designed by Julius Raschdorff and built in 1894-1905 as an imposing Neo-Baroque building with richly decorated interior, the 'Berliner Dom' (Berlin Cathedral) draws on the architectural style of St. Peter's in Rome. Its importance is reflected both by its dominant position facing the 'Lustgarten' (Pleasure Garden) between the 'Altes Museum' (Old Museum) and the former 'Stadtschloss' (City Palace) and by its functions as primary parish church, cathedral and burial church of the Hohenzollerns. The plain building that preceded the cathedral, designed by Knobelsdorff and built by Johann Boumann in 1747-50, was remodelled by Schinkel in Classicist style in 1817-22. However, under pressure from Kaiser Wilhelm II it had to give way to the new showcase building "as the leading church of Prussian Protestantism in Berlin". After being damaged in the War, the cathedral's domes were reconstructed in simplified form.

The northern section of this island on the Spree in the centre of Berlin is made up of a unique ensemble of five major museum buildings, today recognised as a World Heritage Site. The first museums building was the 'Altes Museum' (Old Museum), built between 1825 and 1830, a major work of the Classicist period, is the third-oldest museum building in Germany – after the 'Fridericianum' in Kassel and the 'Glyptothek' in Munich. The transformation of the area into 'Museuminsel' (Museum Island) began in 1830 with the opening of the Old Museum and continued in 1843-45 with the New Museum designed by Friedrich August Stüler, who also drew up the plans for the 'Alte Nationalgalerie' (Old National Gallery), executed from 1866-76 by Johann Heinrich Strack. The Bodemuseum was built from 1897-1904. To plans by Alfred Mesel and under the direction of Ludwig Hoffmann, the construction then followed in 1909-30 of the Pergamon Museum, the world's first museum of architecture. To meet the requirements of a modern museum complex, the buildings are currently being linked underground to a master plan by London architect David Chipperfield. A new entrance building is also being built.

Vorgängerbau (18./19. Jahrhundert) des heutigen Doms um 1825
The building (18th/19th century) that preceded today's cathedral, ca. 1825

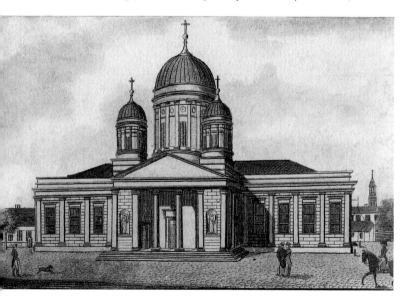

Dom um 1900 (oben)
und heute (unten)

*Cathedral, ca. 1900
(above) and today
(below)*

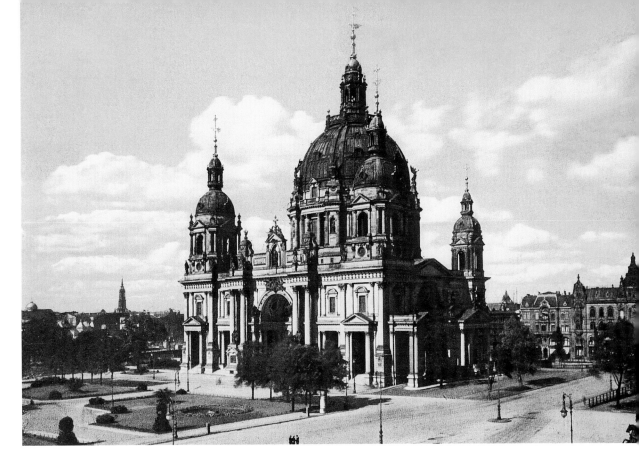

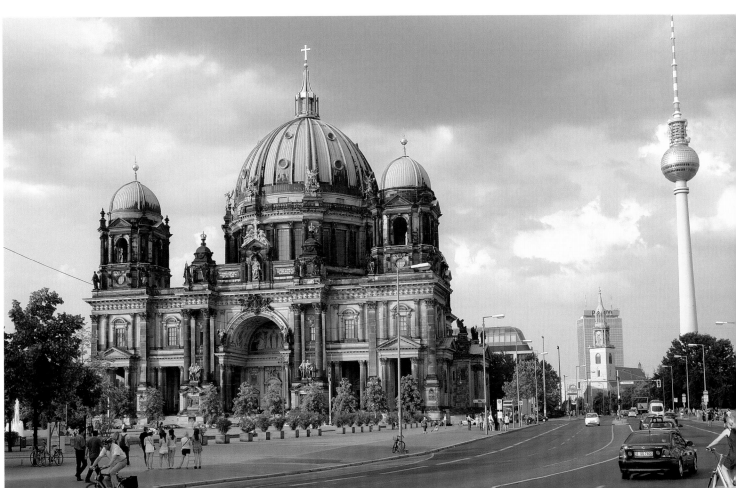

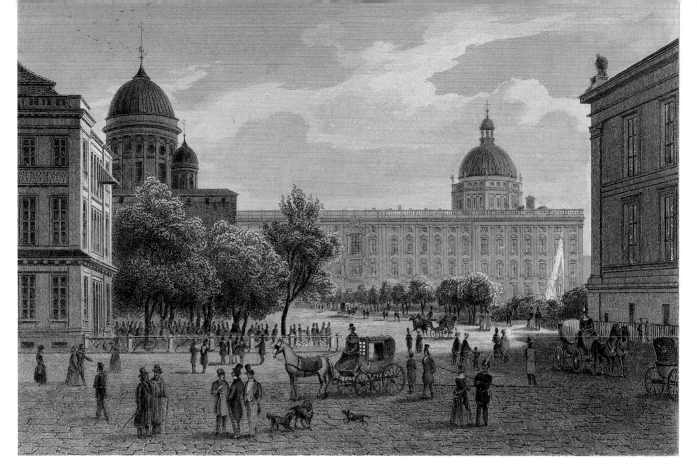

Blick vom Alten Museum zur alten Domkirche und dem Stadtschloss um 1850
View from the Altes Museum (Old Museum) toward the former Cathedral building and the City Palace around 1850

Blick über die Spree zur Börse, dem erneuerten Dom und das Stadtschloss um 1905
View over the river Spree toward the stock exchange, the new Cathedral and the City Palace around 1905

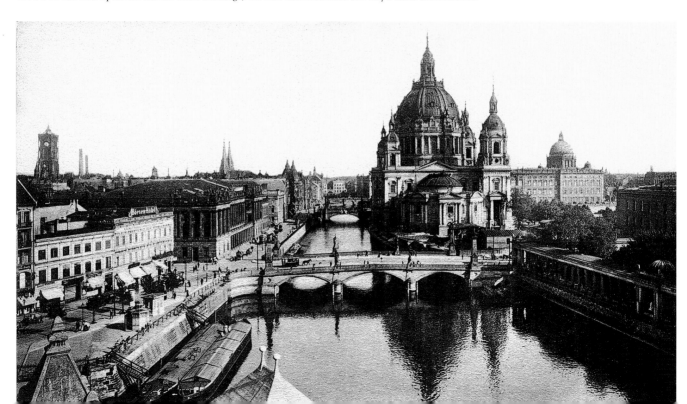

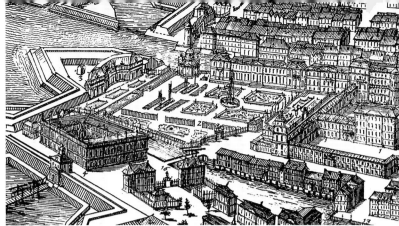

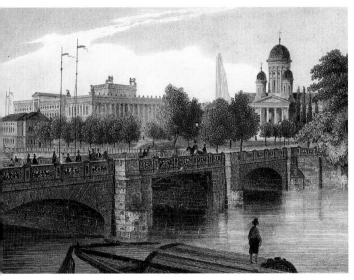

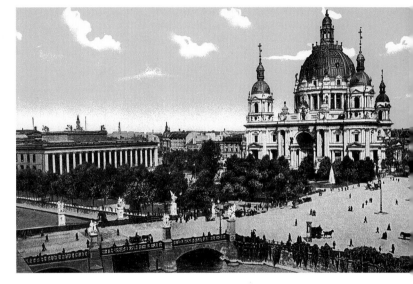

oben: Halbkreisförmiges Pomeranzenhaus von 1685 als architektonischer Abschluss des Lustgartens und das Grottengebäude, Zeichnung von Joh. Stridbeck d. J. 1690 und Merian-Ansicht (s. S. 71)
Mitte: Altes Museum und Dom um 1825 und um 1905
unten: Altes Museum und Dom um 1955 und Ansicht heute

above: Semi-circular Pomeranzenhaus from 1685 as architectural conclusion of the Lustgartens and the Grottengebäude. Drawing by Jo h. Stridbeck the Younger, 1690, and Merian-Ansicht (s. page 71)
center: Altes Museum and Cathedral around1825 and around 1905
below: Altes Museum and Cathedral around1955 and view today

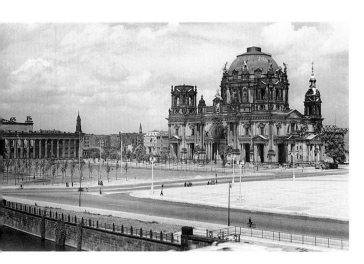

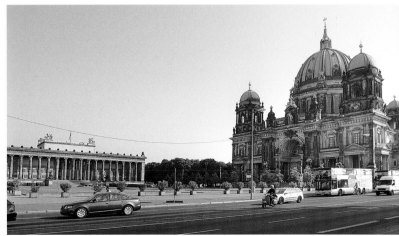

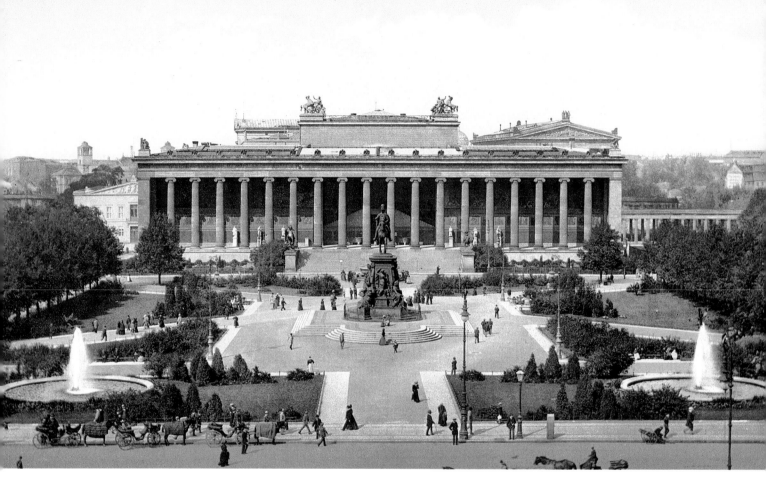

Altes Museum um 1900 und heute *Altes Museum (Old Museum) around 1900 and today*

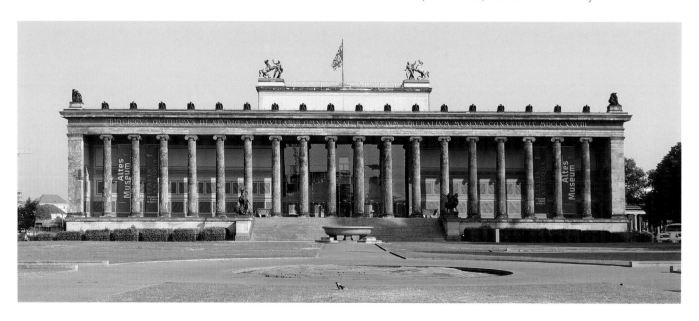

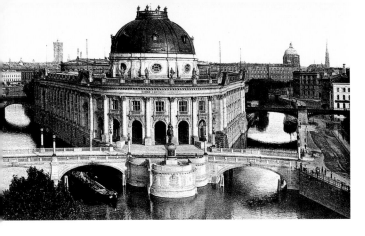

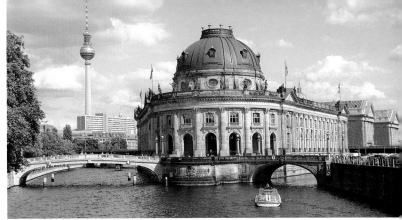

Kaiser-Friedrich-Museum (heute Bode-Museum) um 1910 und heute. An der Spitze der Museumsinsel zwischen den Spreearmen steht der eindrucksvolle Museumsbau, zugänglich über die Monbijou-Brücken. Auf der äußersten Spitze stand das Reiterstandbild Kaiser Friedrichs III., nach dem das Museum benannt wurde.

Kaiser-Friedrich-Museum (now the Bode-Museum) around 1910 and today. The impressive museum structure rises at the tip of the Museum Island between the branches of the Spree, accessible by means of the Monbijou bridges. The equestrian sculpture of Emperor Frederick III., for whom the museum was named, stood at the furthest tip.

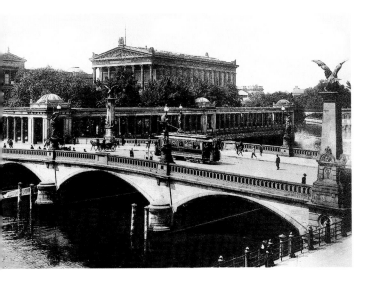

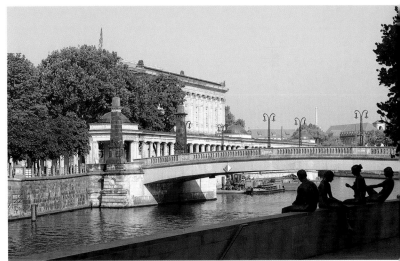

Friedrichsbrücke und Nationalgalerie um 1910 und heute

Friedrichsbrücke and Nationalgalerie around 1910 and today

Am Kupfergraben mit dem Magnushaus von 1756 am linken Bildrand und dem Packhof rechts, der 1910–30 durch das Pergamonmuseum ersetzt wurde, Ansicht um 1835 und heute

Am Kupfergraben with the Magnushaus from 1756 on the left edge of the picture and the Packhof on the right, which was replaced by the Pergamon museum 1910–30, view around 1835 and today

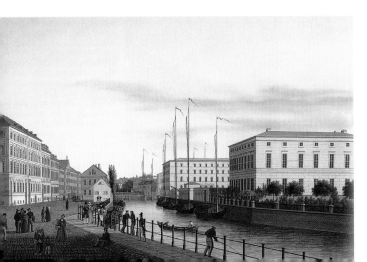

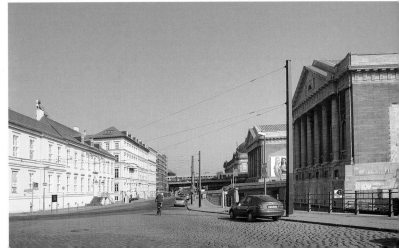

Stadterweiterungen der Barockzeit

Durch die Regierungszeit des „Großen Kurfürsten" Friedrich Wilhelm (1640–88) erhielt die Stadt neuen Auftrieb. Von 1658 bis 1683 ließ der Kurfürst die Stadt einschließlich Residenz und der ersten Neustadt im Westen, Friedrichswerder, mit einem gewaltigen bastionären Festungsring, bestehend aus 13 vorspringenden Bastionen, mächtigen Wällen und breiten Wassergräben, umgeben. Mit der Errichtung der sternförmigen Wasserfestung war Johann Gregor Memhardt (1607–78) betraut worden. Neue Tore und Straßen entstanden und veränderten das Stadtbild. Bis zu 4000 Bürger der Stadt und Bewohner der umliegenden Dörfer mussten täglich an Gräben, Wällen und Bastionen unentgeltlich Arbeit leisten. Zehn Jahre nach ihrer Fertigstellung wurden die Festungsanlagen als militärisch veraltet und überflüssig abgebrochen.

Um 1700 lebten in der Residenzstadt etwa 37 000 Einwohner. Bis 1713 wuchs die Stadt auf bereits 61 000 Einwohner. Aufgrund des Bevölkerungswachstums ließen die Herrscher mehrere Neustädte außerhalb der (ehemaligen) Befestigungsanlage anlegen. So entstand zunächst ab 1674 auf dem Besitz der Kurfürstin die „Dorotheenstadt" mit der späteren Prachtstraße „Unter den Linden", ab 1688 die „Friedrichstadt" unter Friedrich III. Der Ausbau der Stadt vollzog sich von Jahrzehnt zu Jahrzehnt in immer schnellerem Ausmaß. 1709 wurden die Neustädte, die Vorstädte im Norden und Osten und die Kernstadt zu einer Stadt mit dem Namen Berlin zusammengefasst und erhielten eine durch landesherrliche Eingriffsmöglichkeiten geprägte Ratsverfassung.

Die Stadterweiterungen wurden maßgeblich von den Baumeistern Johann Arnold Nering (1659–95) und Philipp Gerlach (1679–1748) vorangetrieben. Berühmtheit erlangte der Architekt und Bildhauer Andreas Schlüter (um 1659–1714). Er entwarf u. a. das Zeughaus und erweiterte das Stadtschloss.

Ab 1737 wurde als neue äußere Abgrenzung der Stadt eine Zollmauer errichtet, die das Land von der Stadt trennte und in der auf Lebensmittel eine indirekte Verbrauchssteuer, die bereits seit 1667 bestand, erhoben wurde. Die militärisch unbrauchbar gewordene Befestigung ließ der König schleifen. An den drei wichtigsten Toren ließ der Preußenkönig große geometrische Plätze nach Pariser Vorbildern, die im Sinne des Absolutismus des französischen Königs Ludwigs XIV. entstanden waren, errichten: ein „Quarree" (Pariser Platz) vor dem Brandenburger Tor, das „Rondell" im Süden (Mehringplatz) und den Leipziger Platz als „Octogon".

City expansions during the Baroque period

The period of rule by the 'Great Elector' Friedrich Wilhelm (1640–88) gave the city new impetus. From 1658 to 1683 the Elector had the city, including the electoral residence and the first new town in the west, Friedrichswerder, encircled by a formidable fortified ring made up of 13 projecting bastions, mighty walls and wide moats. Johann Gregor Memhardt (1607–78) was charged with overseeing the construction of this star-shaped, moated fortification. New city gates were built, new roads laid and the whole city landscape changed. Yet, ten years after they were finished, the fortifications were considered militarily outdated and superfluous and thus demolished.

By around 1700 the city's population numbered some 37,000. By 1713, the city's population had already grown to 61,000. Due to the speed in the growth of the population, the rulers had several new towns created outside of the (former) city fortifications. Initially, for instance, 'Dorotheenstadt', with what would become the grand 'Unter den Linden' avenue, was built on land owned by the Elector's wife, and from 1668 under the rule of Friedrich III, 'Friedrichstadt'

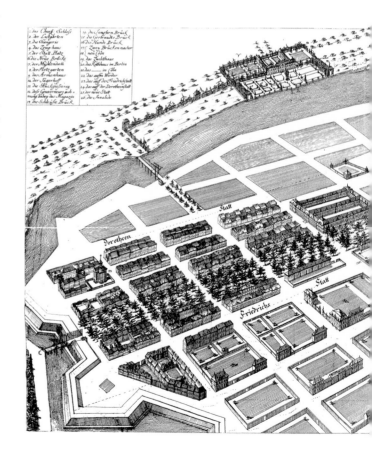

was erected. Decade by decade, the city developed at an increasingly rapid rate. In 1709, the new towns, peripheral towns to the north and east and the core of the city itself were merged into one entity under the name Berlin and were given a city council constitution that was however characterised by opportunities for the rulers to intervene. Work on expanding the city was driven largely by the master builders Johann Arnold Nering (1659–95) and Philipp Gerlach (1679-1748). The architect and sculptor Andreas Schlüter (ca. 1659-1714) also acquired great fame. His designs included the Zeughaus (Armoury) and the extension to the 'Stadtschloss' (City Palace).

In the years following 1737, a customs wall was erected as the city's new outer border, separating the rural areas from the city, in which an indirect consumer tax had been levied on food since 1667. As they had become militarily unusable, the King had the old fortifications razed, while at the three main gates he had created large, geometric open spaces, following the Parisian examples produced as part of the absolutism of the French King, Louis XIV. These were: A 'Quarree' (Pariser Platz) in front of the Brandenburg Gate, the 'Rondell' in the south (Mehringplatz) and Leipziger Platz as an 'Octagon'.

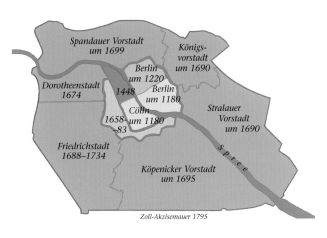

Stadterweiterungen der Doppelstadt Berlin-Cölln und Neustädte bis zum 18. Jahrhundert
Pre-18th century extensions of the twin city of Berlin-Cölln and new towns

unten: Residenzstadt Berlin-Cölln mit Stadterweiterung nach Westen, Merian-Stich des ausgehenden 17. Jahrhunderts. Der perspektivische Plan Berlins zeigt die großen Festungsanlagen, zusätzlich in der Abbildung links die Dorotheenstadt und darunter die Friedrichstadt.

below: The residence city of Berlin-Cölln showing the spread of the city to the west: Engraving by Merian from the late 17th century. The 3-D plan of Berlin shows the extensive fortifications. To the left in the picture you can also see Dorotheenstadt, with Friedrichstadt below it.

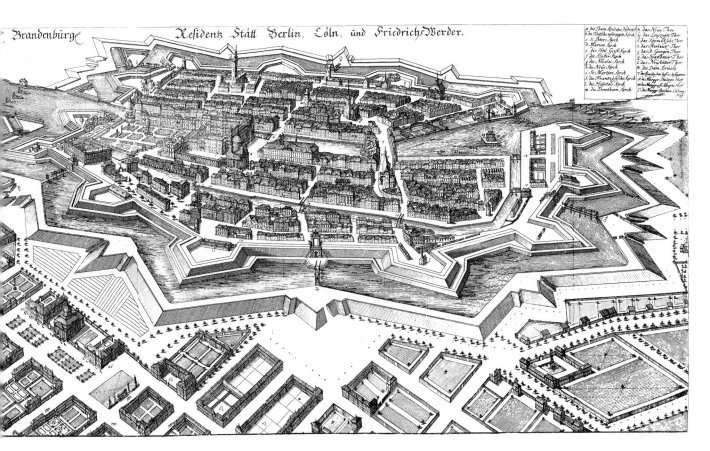

Bauakademie,
1832–36 von
Schinkel, Radie-
rung um 1840
(oben), nach
Kriegsschäden
1961 abgerissen,
Rekonstruktion
heute (unten)

*Schinkel's
Bauakademie
(Academy of
Architecture).
Original built
1832–36 (print
around 1840,
above), demolished
1961. Reconstruc-
tion today (below)*

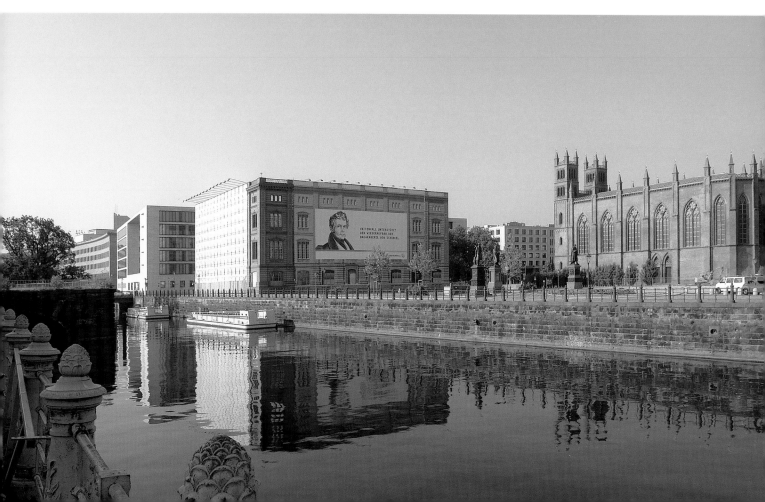

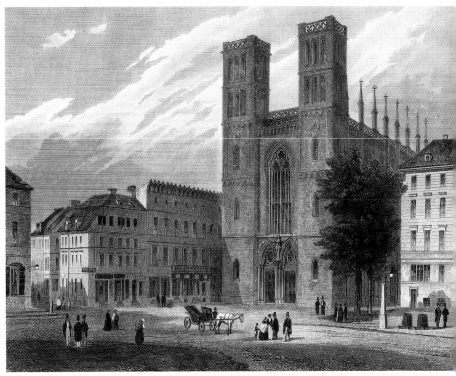

Friedrichwerdersche Kirche um 1830 (oben) und heute
(unten rechts). Von Karl Friedrich Schinkel 1821–22 ent-
worfen und 1824–30 errichtet und ursprünglich dicht
von Häusern umbaut, war sie nicht nur der erste neugo-
tische Sakralbau Berlins, sondern auch der erste Reprä-
sentationsbau seit dem Mittelalter mit unverputzter
Backsteinfassade.

*Friedrichwerdersche Kirche around 1830 (above) and today
(below right). Designed by Karl Friedrich Schinkel in 1821–22
and built in 1824–40, originally surrounded by dense housing,
was not only Berlin's first Neo-Gothic ecclesiastical building, but
also the first showcase building since the Middle Ages to have an
unplastered brick façade.*

unten: DDR-Außenministerium von 1964–67 ersetzte
Schinkels Bauakademie und wurde 1995 abgebrochen

*below: The foreign ministry building of the GDR (built from
1964–67) replaced Schinkel's Academy of Architecture and
was torn down in 1995*

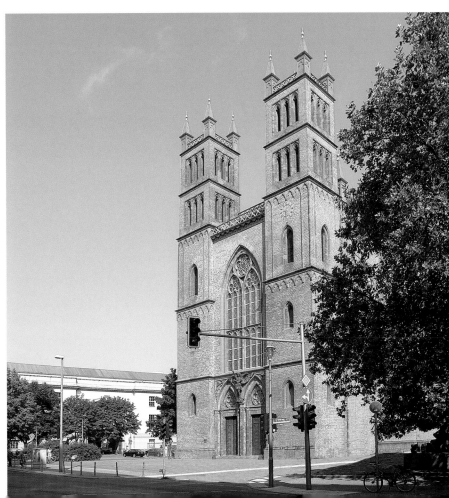

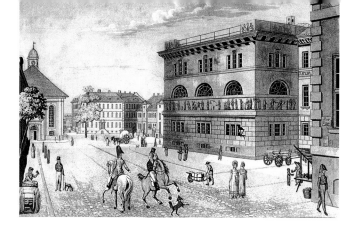

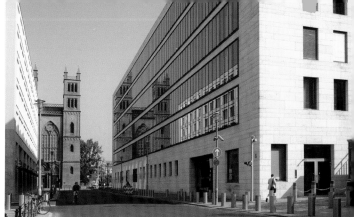

unten und oben: Königliche Münze von 1798 nach Plänen von H. Gentz, eines der berühmtesten Bauten der „Revolutionsarchitektur" Deutschlands, Ansicht um 1800/10 mit barocker Friedrichwerderscher Kirche (links) und heutige Situation (rechts) mit dem Neubau des Bundesministeriums für Auswärtige Angelegenheiten von Thomas Müller und Ivan Reimann (1997–99) sowie der neugotischen Friedrichwerderschen Kirche (1824–31) von Schinkel

above and below: The Royal Mint, 1798, was designed by H. Gentz. It is one of the most famous examples of "revolutionary architecture" in Germany. Printings around 1800/10 with the baroque Friedrichwerdersche Kirche (left) and today's situation (right) with the new Federal Ministry for Foreign Affairs, by Thomas Müller and Ivan Reimann, 1997–99, and the gothic revival Friedrichwerdersche Kirche, 1824–31, designed by Schinkel

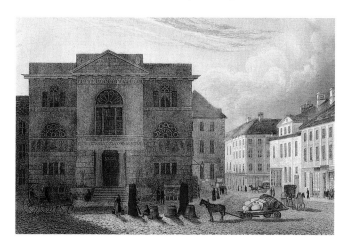

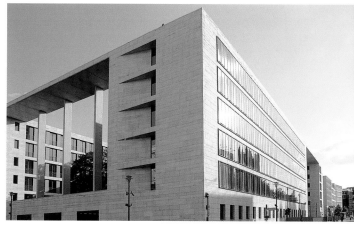

unten: Über den Festungsgräben entstanden im 18. Jahrhundert steinerne Brücken, auf denen repräsentative Schauarchitekturen im Auftrag des Königs errichtet wurden, wie die Mohrenkolonnaden von 1787 in der Mohrenstraße von Langhans – Stich um 1780 und heute

below: During the 18th century, stone bridges began to be built over the moats of the fortifications. The king commissioned splendid showpiece structures to be erected on these bridges like Langhans' Mohrenkolonnaden on Mohrenstraße, built in 1787 – print about 1780 and picture today

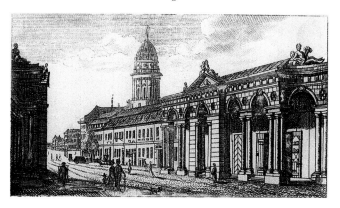

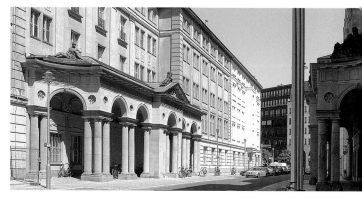

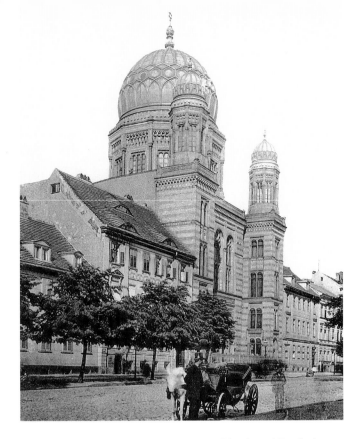

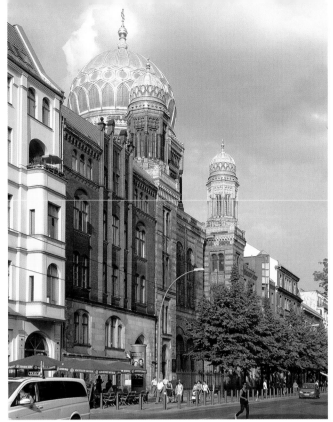

Neue Synagoge (1859–66) von Eduard Knoblauch und Friedrich August Stüler in der Oranienburger Straße, Fotos um 1870 und heute

The New Synagogue (1859–66) on Oranienburger Straße, built by Eduard Knoblauch and Friedrich August Stüler, photos around 1870 and today

Postfuhramt (Oranienburger Straße 35/36), 1875–81 für verschiedene Posteinrichtungen erbaut. Der Architekt Carl Schwatlo ließ einen repräsentativen, unterschiedlich farbigen Ziegelrohbau mit figürlichen Darstellungen ausführen. In den hofseitigen Stallgebäuden konnten in zwei Geschossen 200 Pferde Platz finden (Fotos um 1870 und heute).

Postfuhramt (Old Post Office, 35/36 Oranienburger Straße), built 1875–81 for various post office functions. The architect Carl Schwatlo had a showcase, brick building constructed, varying in colour and with decorative figures. The two-storey stable buildings on the courtyard side had room for 200 horses – photos around 1870 and today.

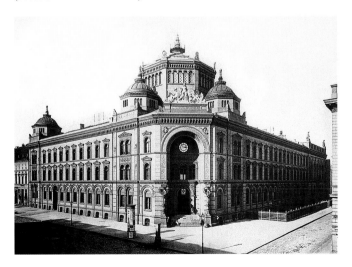

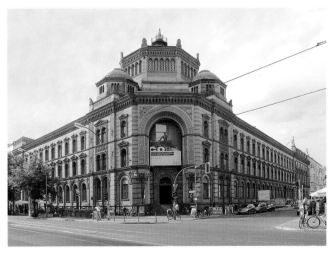

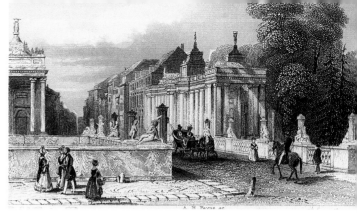

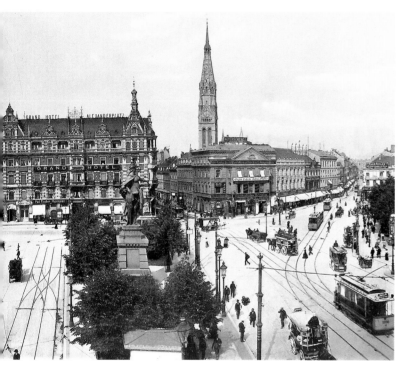

linke Spalte: Alexanderplatz, Ansicht nach Osten um 1800,
um 1900 und heute. Das Foto links zeigt die 7,5 m hohe
Kolossalfigur der Berolina, eine Allegorie der Stadt Berlin,
auf 6,5 m hohem Sockel, 1895 nach Entwurf von Emil
Hundrieser errichtet und 1944 eingeschmolzen.
left column: Alexanderplatz, view toward the east around 1800,
around 1900 and today. The picture left shows the 7,5 meter tall
colossal statue of Berolina, an allegory for the city of Berlin. It was
created by Emil Hundrieser , was 7.5 meters tall and stood on a
6.5 meters tall pedestal. It was melted down in 1944.

oben: Königskolonnaden, 1777–80 von Carl von Gontard erbaut,
Kupferstich um 1810. Sie waren eine Brückenkolonnade als letzter
Abschnitt der in den Alexanderplatz einmündenden Königsstraße
(seit 1910/11 in Kleistpark, Berlin-Schöneberg, aufgestellt)
above: Königskolonnaden ('King's Colonnades'), built from 1777–80 by
Carl von Gontard, print around 1810. They formed bridge colonnades as
the final section of Königsstraße, which opens up onto Alexanderplatz
(since 1910/11 they have been in Kleistpark in Berlin-Schöneberg).

unten: Königsstädtisches Theater am Alexanderplatz, Radierung
um 1830
below: Königstädtische Theater at the Alexanderplatz, print around
1830

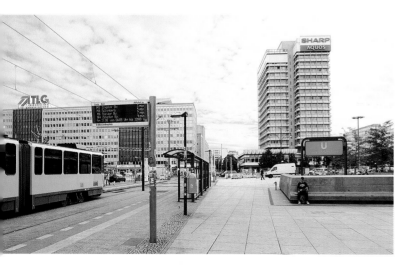

Blick zum
Alexanderplatz
in Richtung
Königstraße
(später Rathaus-
straße) mit dem
Warenhaus Tietz
um 1910

*View of the
Alexanderplatz
looking toward
Königstraße (later
Rathausstraße)
with the Tietz
department store
around 1910*

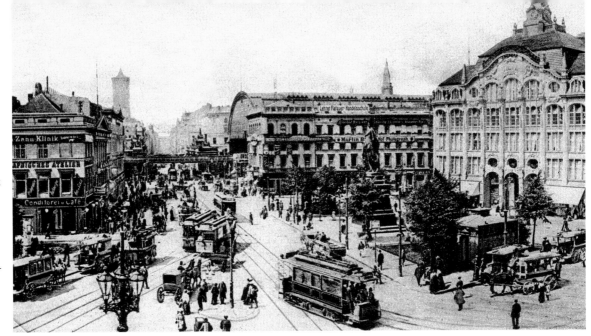

Blick zum
Alexanderplatz
in Richtung
Königstraße
(später Rathaus-
straße) um 1934

*View of the
Alexanderplatz
looking toward
Königstraße (later
Rathausstraße)
around 1934*

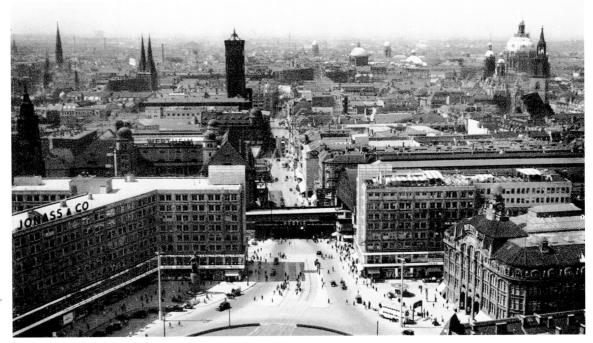

Alexanderplatz
heute

*Alexanderplatz
today*

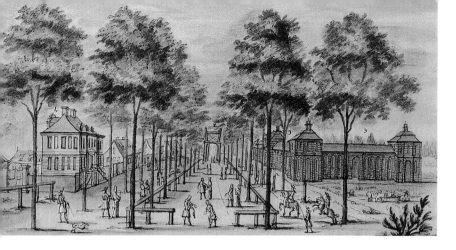

Der Prachtboulevard „Unter den Linden" mit Ausrichtung auf das Brandenburger Tor ist das Pendant zur Pariser Avenue des Champs-Elysées mit dem Arc de Triomphe. Der 1573 angelegte Reitweg, der vom Schloss zum königlichen Jagdrevier im Tiergarten führte, wurde 1647 als 1,2 km lange und 60 m breite, mit Linden bepflanzte Straße angelegt. Ihre repräsentative Gestalt erhielt sie erst im Zuge der barocken Stadterweiterung im 18. Jahrhundert.

The grand boulevard „Unter den Linden" leading up to the Brandenburg Gate is the counterpart of the Champs-Elysée and the Arc de Triomphe in Paris. Initially laid out in 1573 as a bridal path from the Schloss to the royal hunting grounds in the Tiergarten, it was turned into an avenue lined with linden trees, 60 metres wide and 1.2 kilometres long, in 1647. It was first given its look of pomp and grandeur in the course of the Baroque expansion of the city in the 18th century.

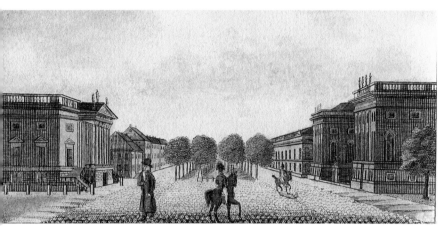

Unter den Linden, Ansicht vom Stadtschloss nach Westen, Zeichnung, 1690 von Johann Stridbeck (oben), Kupferstich um 1800 (links) und Kupferstich von Johann Georg Rosenberg 1780 (unten)

Unter den Linden. View west from the City Palace. Drawing by Johann Stridbeck, 1690, Copper etching around 1800 (left) and copper etching by Johann Georg Rosenberg, 1780 (below)

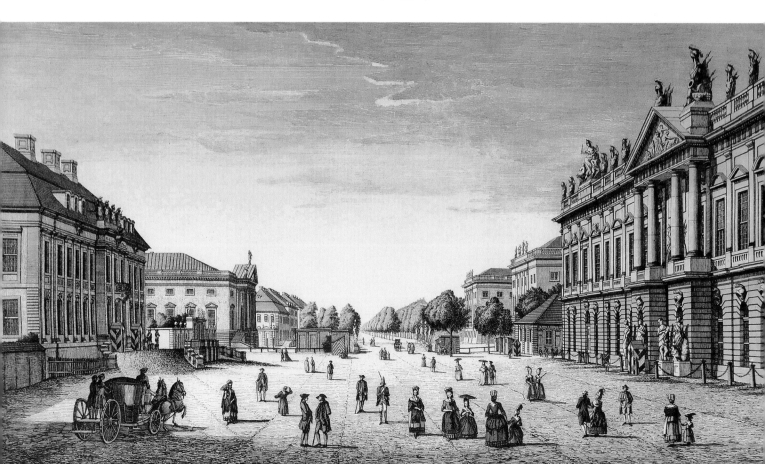

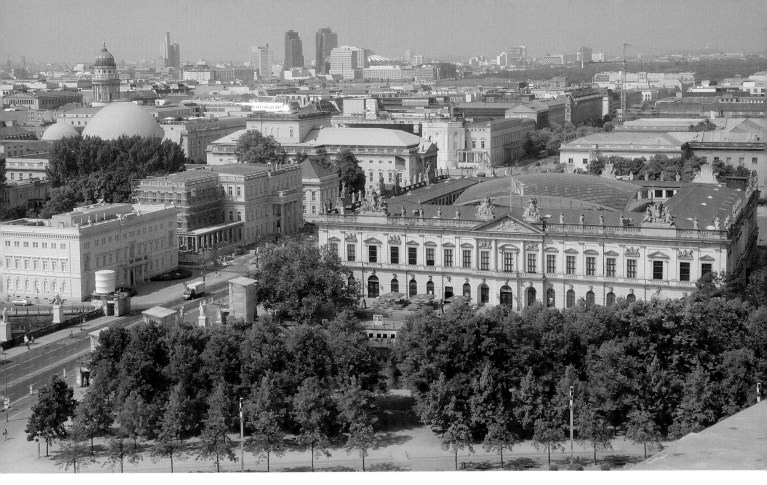

oben: Unter den Linden im frühen 21. Jahrhundert, Blick vom Berliner Dom zur Kommandantur, zum Kronprinzenpalais, Prinzessinnenpalais, Opernhaus (links davon die St.-Hedwigs-Kathedrale) und Zeughaus
rechts: Unter den Linden, heutige Ansicht nach Westen mit dem Zeughaus rechts

above: Unter den Linden in the early 21st century. View from Berlin Cathedral to the military headquarters building, the Crown Prince's palace, Princess's palace, Opera House (with St. Hedwig's Cathedral to the left) and the Armoury
right: Unter den Linden. View west with the Zeughaus

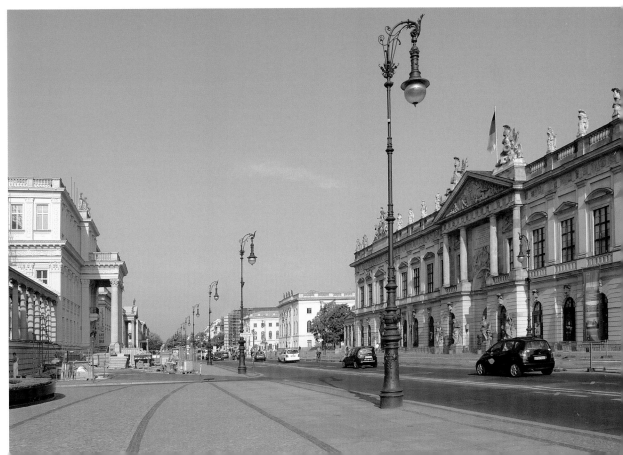

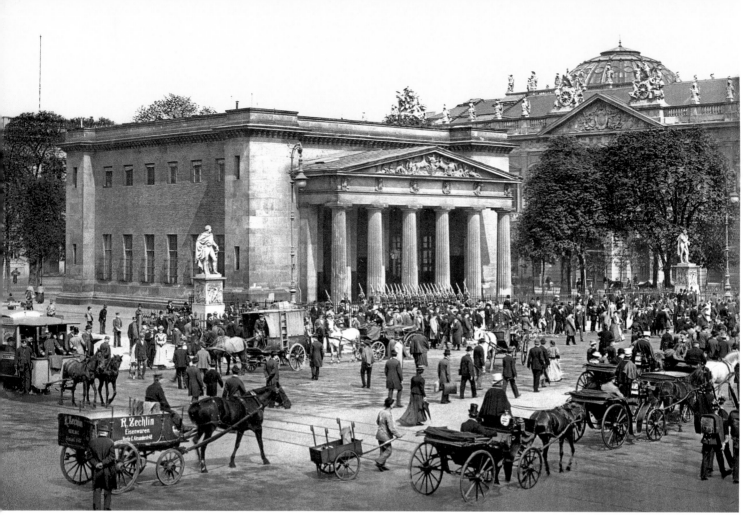

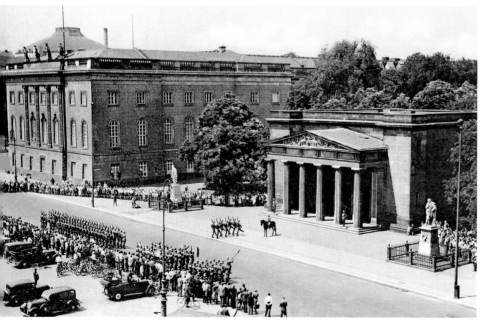

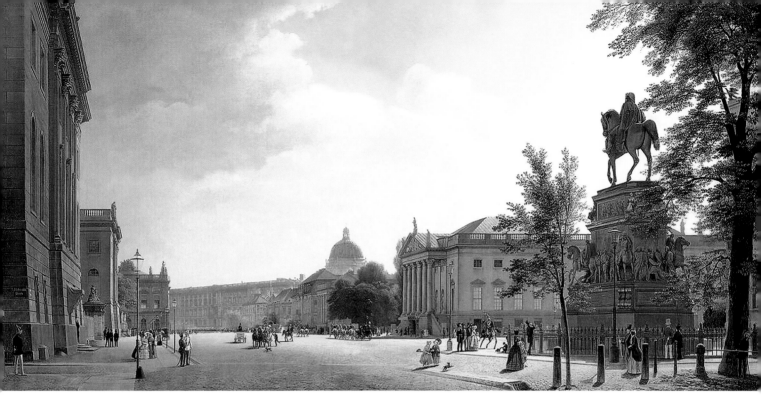

oben: Unter den Linden, Gemälde von Eduard Gärtner von 1852
mit Blick vom Westflügel des Universitätsgebäudes und dem Reiter-
standbild Friedrichs des Großen über das Opernhaus zum Stadt-
schloss
unten rechts: Kronprinzenpalais und die Oper um 1900
links: Neue Wache, 1816–18 nach Plänen Schinkels erbaut, Ansichten
um 1900 (oben), um 1930 (unten links) und heute (unten Mitte)

*above: Unter den Linden, painting by Edaurd Gärtner, 1852. View
from the west wing of the university building and the memorial of
Frederick the Great past the Opera House on the right to the City
Palace*
below right: Kronprinzenpalais and Opera House around 1900
*Left: Neue Wache (New Watchhouse), built in 1816–18 by Karl Fried-
rich Schinkel, around 1900 (above), around 1930 and today (below)*

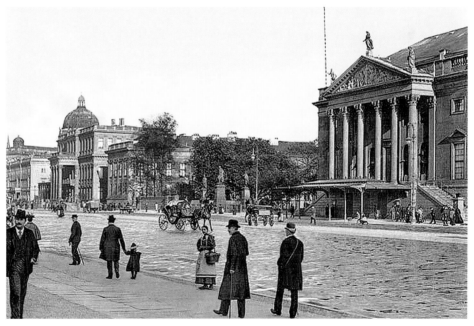

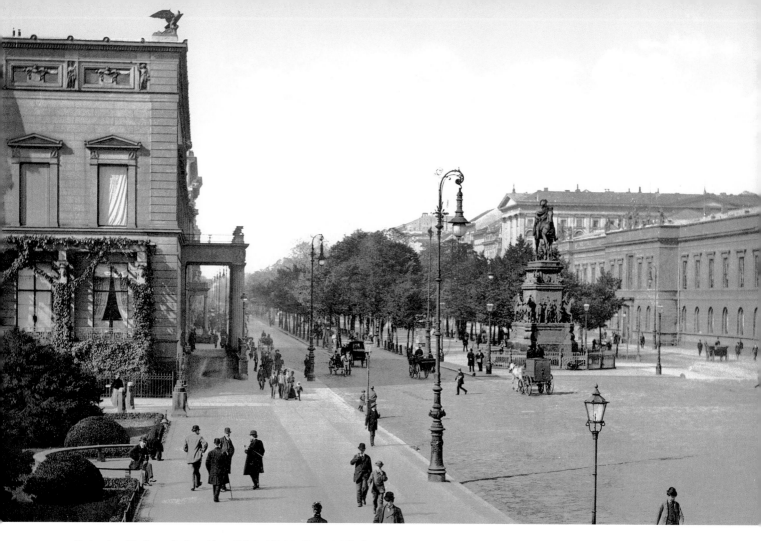

Unter den Linden mit dem Alten Palais („Palais Kaiser Wilhelms I.") und dem Reiterstandbild Friedrichs des Großen von Christian Daniel Rauch aus den Jahren 1836–51, Ansichten um 1900 und heute

Unter den Linden with the Altes Palais („Palais Kaiser Wilhelm I.") and the memorial of Frederick the Great, 1836–51, by Christian Daniel Rauch, photos around 1900 and today

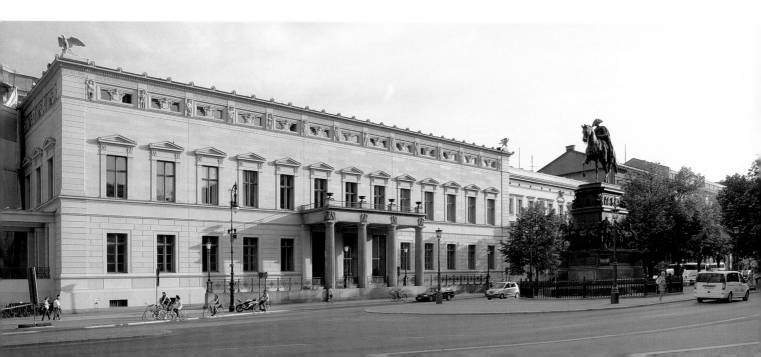

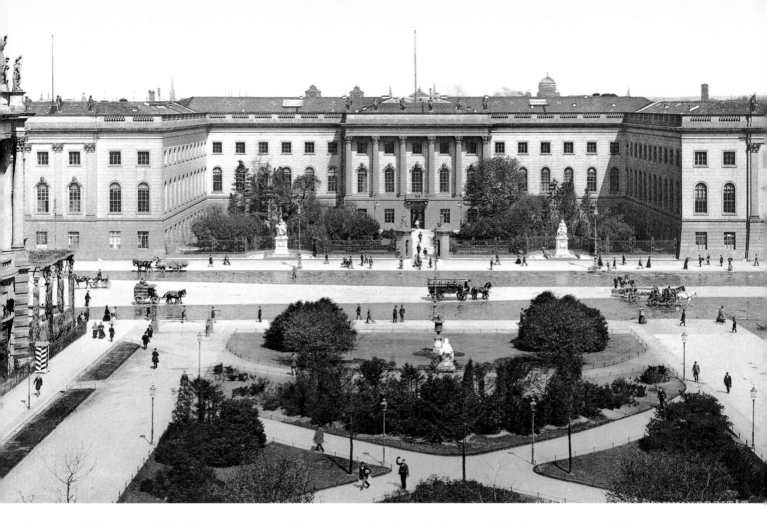

Die Humboldt-Universität (1748–53) – Ansichten um 1900 und heute – war ursprünglich das Stadtpalais Prinz Heinrichs, des Bruders Friedrichs d. Großen. Auf Betreiben Wilhelm von Humboldts, dessen Denkmal vor dem Eingang steht, wurde 1810 das Gebäude für die 1809 gegründete Universität freigegeben und 1913–20 unter Ludwig Hoffmann erweitert.

The Humboldt University (1748–53), photos around 1900 and today, was originally the city palace of Prince Heinrich, the brother of Frederick the Great. At the instigation of Wilhelm von Humboldt, a monument to whom stands in front of the main entrance, the building was released in 1810 for the university, which had been founded a year earlier. In 1913–20, it was extended under the direction of Ludwig Hoffman.

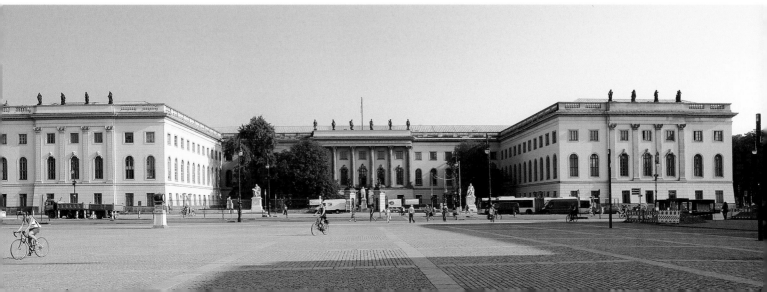

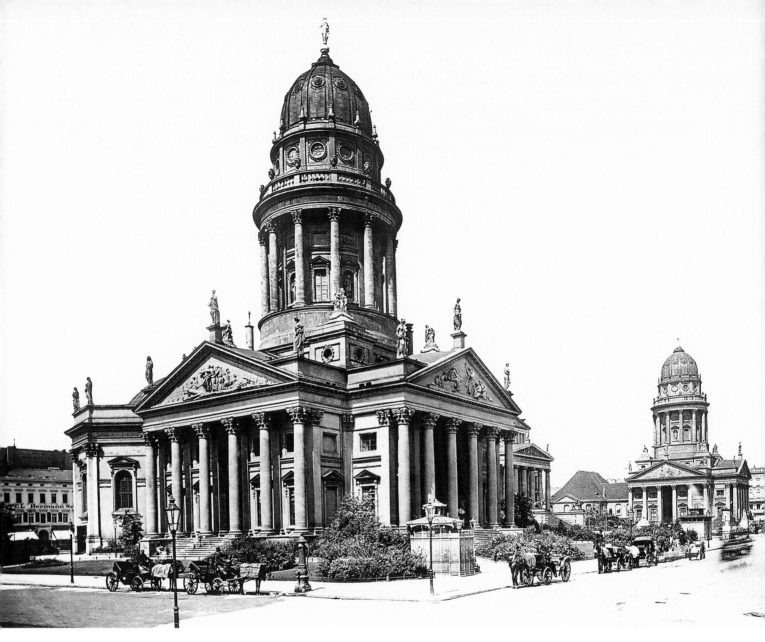

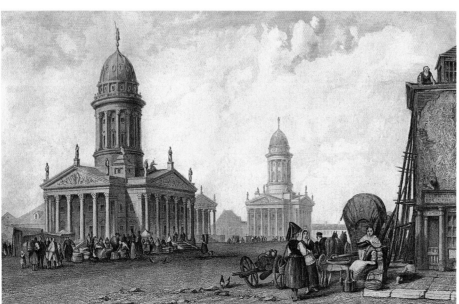

Gendarmenmarkt, kolorierter Kupferstich Ende 18. Jahrhundert (links), Fotos um 1880 (oben) und heute (S. 85)

Gendarmenmarkt, colored print at the end of the 18th century (left), photos around 1880 (above) and today (page 85)

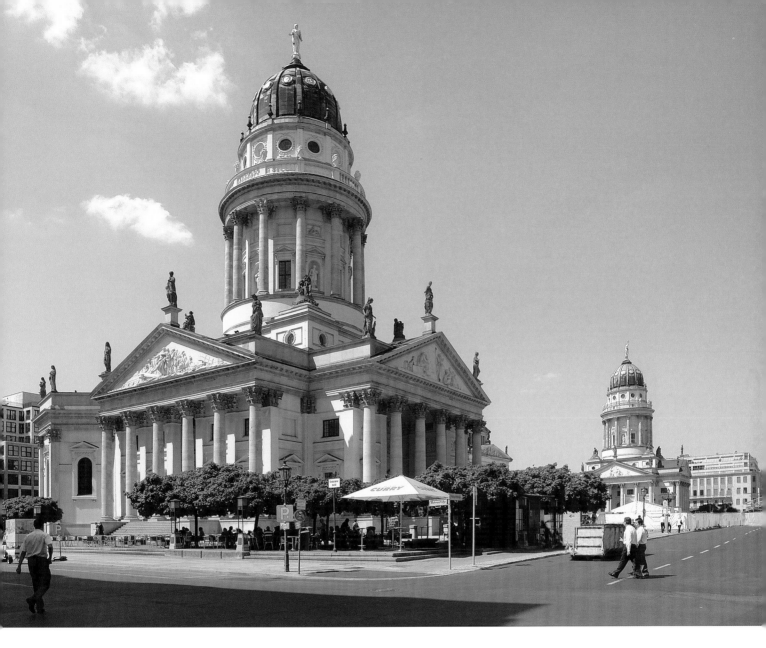

Gendarmenmarkt

Der Gendarmenmarkt war der einstige Hauptmarkt der unter dem Kurfürsten Friedrich III. 1688 angelegten Friedrichstadt. Die Bebauung des Gendarmenmarktes begann mit der Errichtung des Französischen und des Deutschen Doms im nördlichen bzw. südlichen Teil des Platzes. Der von Louis Gayard entworfene Französische Dom (1701–05) wurde für die Hugenottengemeinde als querovaler Saalraum nach dem Vorbild der 1624 erbauten und 1688 zerstörten Hugenottenhauptkirche in Charenton errichtet. Den mächtigen Kuppel-

Gendarmenmarkt

The 'Gendarmenmarkt' was the erstwhile main market of Friedrichstadt, planned in 1688 on instruction of Elector Friedrich III. The first buildings to be built around Gendarmenmarkt were the French and German cathedrals on the square's north and south sides respectively. Designed by Louis Gayard, the French Cathedral (Französischer Dom, 1701–05) was built for the Huguenot community as a transverse oval hall, modelled on the Huguenot church in Charenton, built in 1624 and destroyed in 1688. The mighty domed tower was added in 1780–85 to plans by Carl von

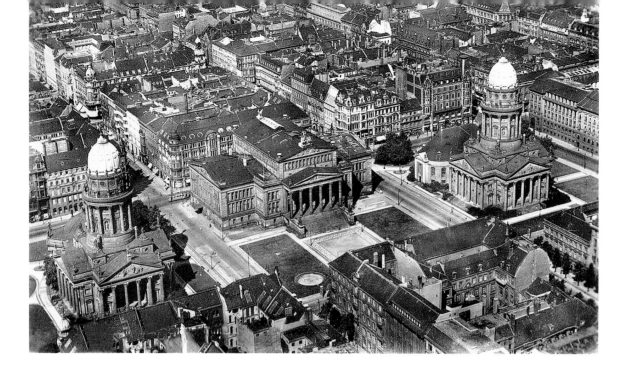

turm fügte man nach Entwürfen Carl von Gontards 1780–85 an. Der Deutsche Dom entstand 1701–08 nach Plänen von Martin Grünberg als fünfseitiger Zentralbau. Die Kirche erhielt gleichfalls ab 1780 von Carl von Gontard ihren markanten Kuppelturm. Den ursprünglichen Kirchenbau ersetzten 1881/82 Hermann von der Hude und Julius Hennicke durch einen Neubau.

Im Zentrum des Platzes steht das Schauspielhaus (1818–21) von Karl Friedrich Schinkel, ein Hauptwerk des Klassizismus.

Gontard. The German Cathedral (Deutscher Dom) was built in 1701–08 to plans by Martin Grünberg. In the years after 1780, this cathedral too was given its striking domed tower by Carl von Gontard. The original cathedral building was replaced with a new one by Hermann von der Hude and Julius Hennicke in 1881/82.

In the centre of the square is Karl Friedrich Schinkel's 'Schauspielhaus' (theatre, 1818–21), a major work of the Classicist period.

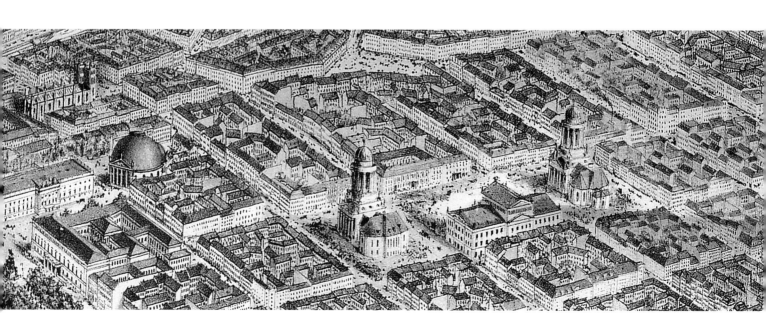

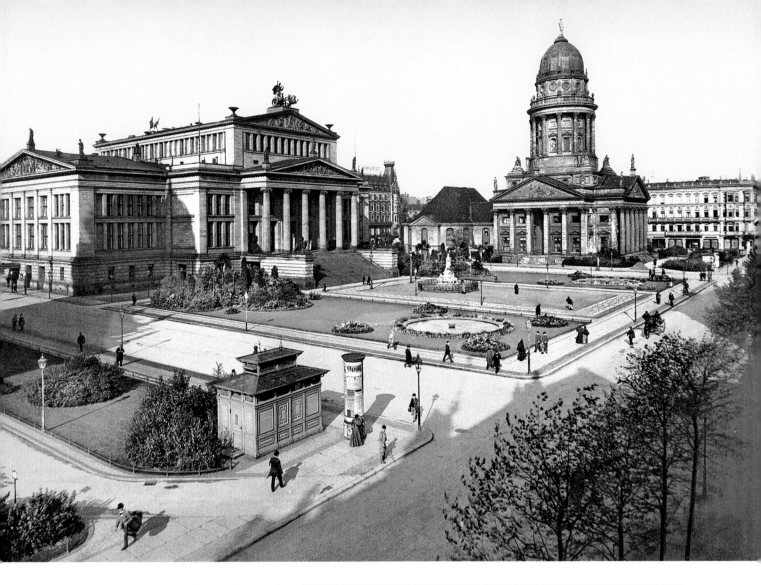

oben: Gendarmenmarkt mit dem Schauspielhaus Karl
Friedrich Schinkels von 1818–21 und dem Französi-
schen Dom um 1900

above: Gendarmenmarkt with the Schauspielhaus (theatre),
built in 1818–21, designed by Karl Friedrich Schinkel, and
the Französische Dom around 1900

rechts: Gendarmenmarkt mit dem Deutschen Dom
und dem 1802 erbauten und 1817 durch Brand
zerstörten Nationaltheater von Carl Gotthard Lang-
hans, von dem die Portikussäulen für den Nachfolge-
bau Schinkels übernommen wurden, Stich um 1805

right: Gendarmenmarkt with the German Cathedral and
Carl Gotthard Langhans' National Theatre, built in 1802
and destroyed by fire in 1817, from which the portico
pillars were used for the replacement building, designed by
Schinkel. Etching ca. 1805

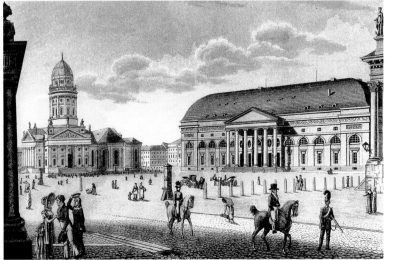

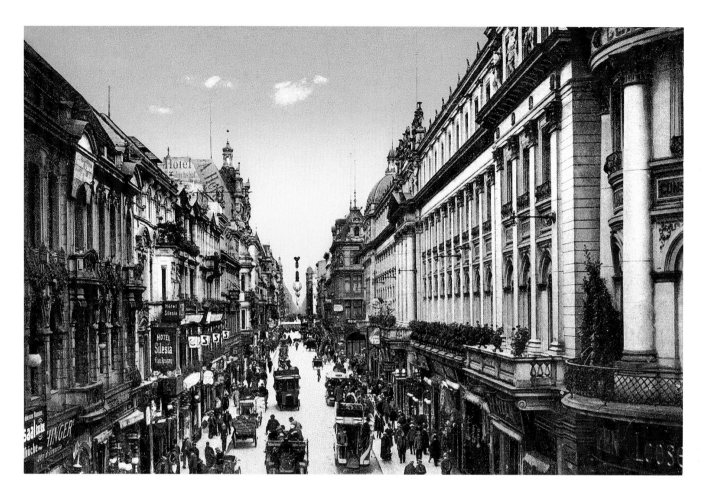

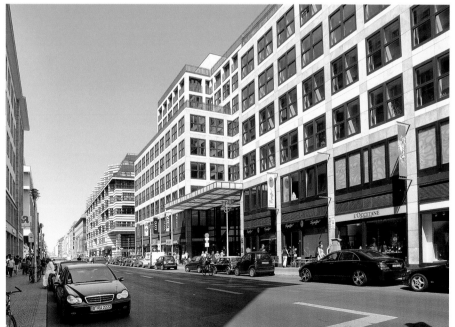

Friedrichstraße um 1910 und heute.
Die Friedrichstraße ist mit einer Länge
von 3,3 km die längste Straße im Zentrum
Berlins. Sie wurde im 19. Jahrhundert zur
Einkaufsstraße der Stadt.

*Friedrichstraße around 1910 and today.
With a length of 3.3 kilometers, the
Friedrichstraße is the longest street in the
center of Berlin. Leipziger Straße became the
„shopping street" during the 19th century.*

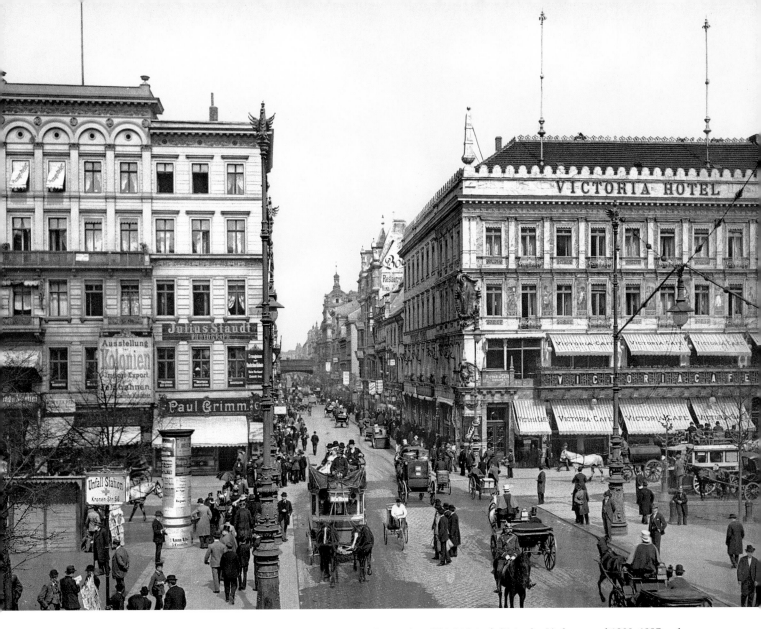

Ecke Friedrichstraße/Unter den Linden um 1900, 1937 und heute. Das elegante Victoria Café befand sich im Gebäude rechts. Das Haus gegenüber wurde 1934–36 durch das „Haus der Schweiz" ersetzt.

Intersection of Friedrichstraße/Unter den Linden around 1900, 1937 and today. The extremely elegant Victoria Café was located on the right. The house across from it was replaced in1934–36 by the „Haus der Schweiz".

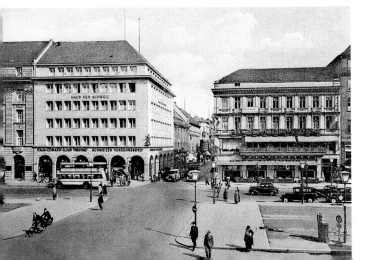

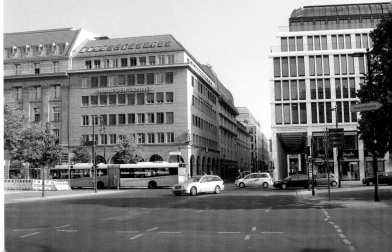

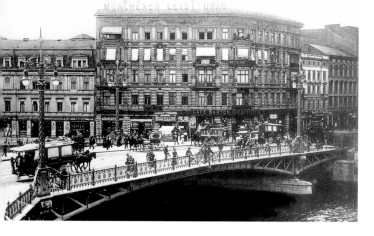
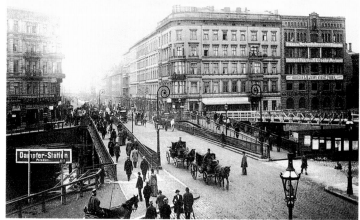

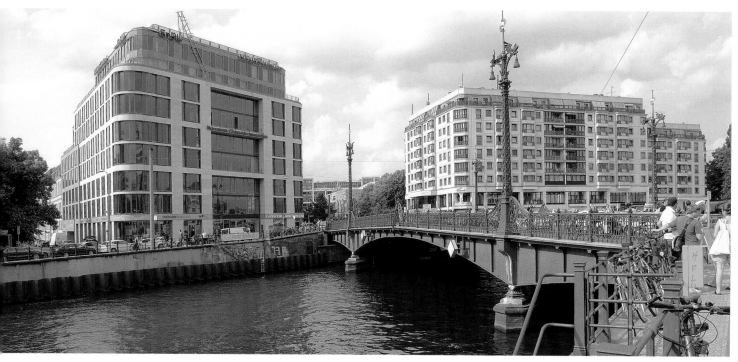

Weidendammbrücke/Friedrichstraße, Blick nach Norden um 1910
und heute (oben) und nach Süden um 1910 und heute (unten)

*Weidendammbrücke/Friedrichstraße, view toward the north ca. 1910
and today (above) and toward the south ca. 1910 and today (below)*

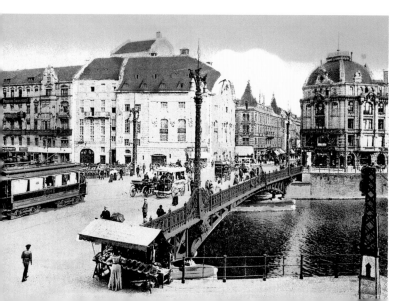
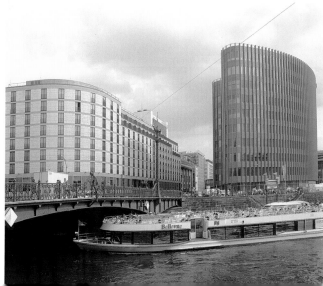

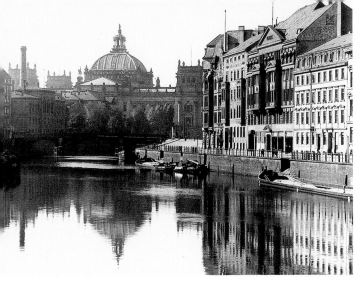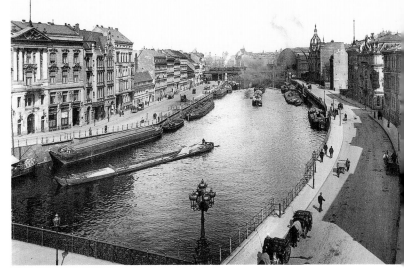

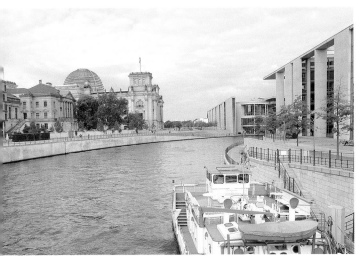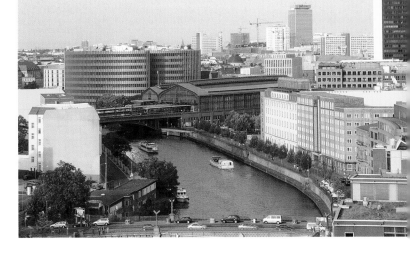

Blick von Osten zum Reichstagsgebäude um 1910 und heute
(oben links) und vom Reichstagsufer zum Bahnhof Friedrichstadt
um 1910 und heute (oben rechts)
unten: Theater am Schiffbauerdamm um 1933 und heute

*View from the east toward the Reichstags Buildung ca. 1910 and today
(above left) and from the Reichstagsufer toward the Friedrichstadt train
station ca. 1910 and today (above right)
below: Theater am Schiffbauerdamm ca. 1933 and today*

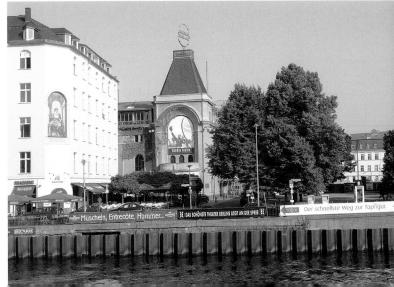

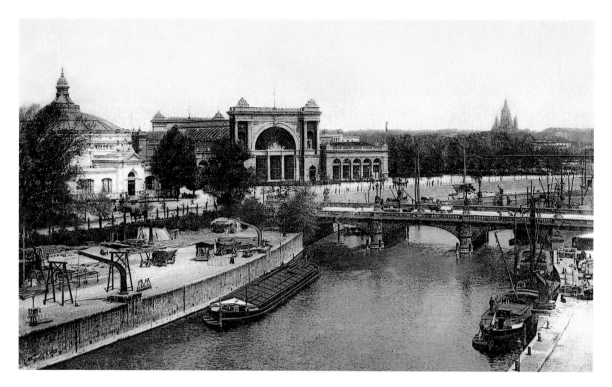

Lehrter Bahnhof (oben), erbaut 1869–71 von B. Scholz und La Pierre, und heutige Situation als Berliner Hauptbahnhof von 1998–2006 des Architekten Meinhard von Gerkan (unten)
Lehrter Bahnhof (above), built in 1869–71 by B. Scholz and La Pierre, and today's scene as Berliner Hauptbahnhof, 1998–2006, by Meinhard von Gerkan (below)

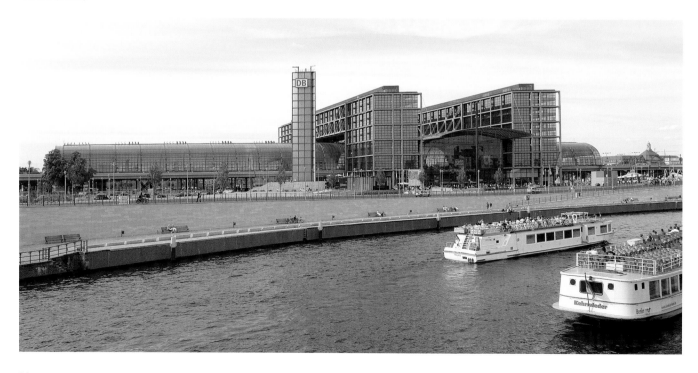

oben: Adolf Hitlers Neue Reichskanzlei von 430 m Länge wurde nach Plänen von Albert Speer als Ergänzung der alten Reichskanzlei und des 1928–30 errichteten Erweiterungsbaus zur Reichskanzlei zwischen 1934 (Planungsbeginn) und 1943 (Einstellung der Bauarbeiten) in der Voßstraße und Wilhelmstraße erbaut.
oben rechts: Heutige Situation

above left: Adolf Hitler's New Reich's Chancellery, with a length of 430 meters was built according to plans by Albert Speer as an addition to the Old Reich's Chancellery and the expansion of the Reich's Chancellery built in 1928–30 between 1934 (beginning of planning) and 1943 (cessation of construction work) on Voßstraße and Wilhelmstraße.
above: Today's scene

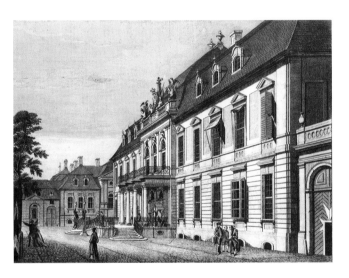

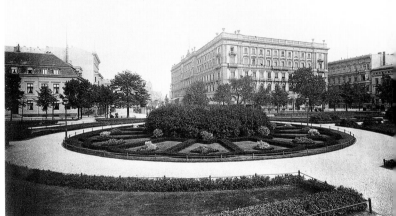

Wilhelmstraße und Wilhelmsplatz bildeten das Regierungsviertel der Reichshauptstadt; oben: Ordenspalais um 1785; oben rechts: Wilhelmsplatz mit dem Luxushotel Kaiserhof um 1910; unten: Wilhelmsplatz nach Westen um 1910; unten rechts: heutige Situation

Wilhelmstraße and Wilhelmsplatz formed the government district of the capital of the Reich; above: Ordenspalais around 1785; above right: Wilhelmsplatz with the Kaiserhof luxury hotel around 1910; below: Wilhelmsplatz toward the west around 1910; above: today's scene

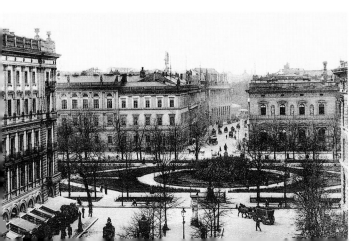

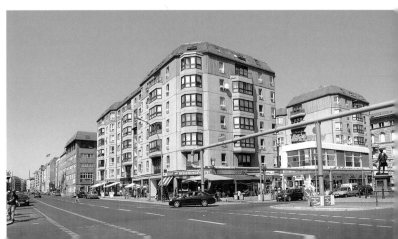

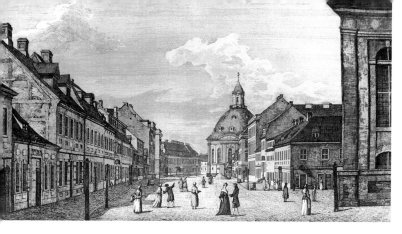
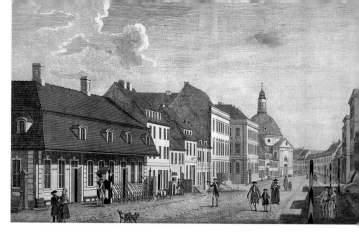

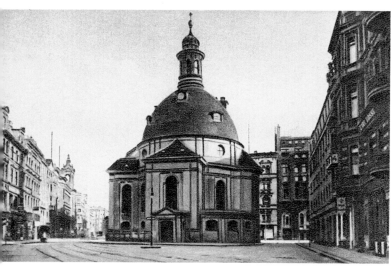
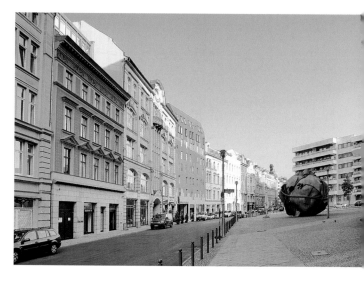

Mauerstraße mit Bethlehemskirche, die 1735–37 unter Leitung von Friedrich Wilhelm Diterichs auf kreisrundem Grundriss für die aus religiösen Gründen verfolgten und ausgewanderten böhmischen Protestanten errichtet, im 2. Weltkrieg stark beschädigt und danach abgetragen wurde, Ansichten um 1780 (oben), um 1910 (Mitte links) und heutige Situation (Mitte rechts)

unten: Taubenstraße/Ecke Glinkastraße um 1920 und heute. Zwei der ursprünglich drei Pfarrhäuser von 1738/39 der zerstörten Dreifaltigkeitskirche. Es sind die einzigen erhaltenen barocken Wohnhäuser der Friedrichstadt und wurden nach Plänen des Baumeisters der Dreifaltigkeitskirche, Titus Favre, erbaut.

Mauerstraße with Bethlehemskirche, which was constructed in 1735–37 under the direction of Friedrich Wilhelm Diterichs on a round foundation for the Bohemian protestants, who were persecuted for religious reasons and emigrated, heavily damaged in World War II and then demolished. Views around 1780 (above), around 1910 (center left) and today (center right)

below: Corner of Taubenstraße and Glinkastraße around 1920 and today. Two of the destroyed Trinity Church's original three manse houses dating from 1738–39. They are the only Baroque houses from Friedrichstadt remaining and were built to plans by Titus Favre, architect of the 'Dreifaltigkeitskirche' (Trinity Church).

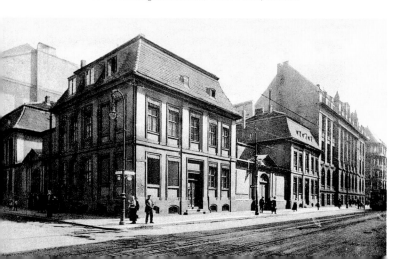
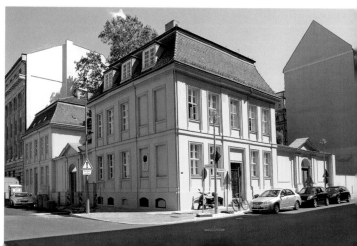

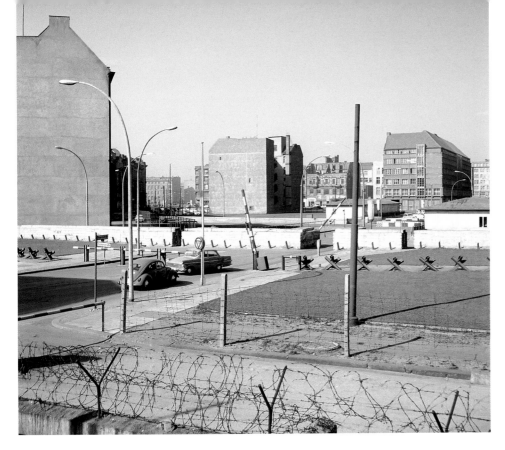

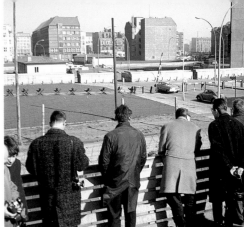

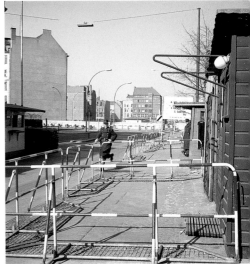

Checkpoint Charly, ehemaligen Mauer-Kontrollpunkt (1961–89) im Jahr 1965 (oben und rechts) und heute (unten)

Checkpoint Charlie. Former Berlin Wall control point (1961–89) in 1965 (above an right) and today (unten)

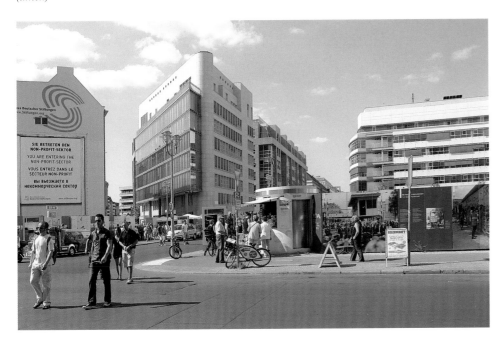

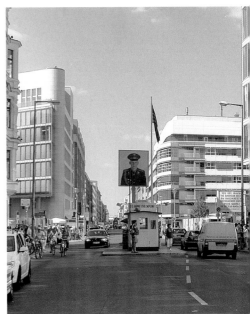

Brandenburger Tor

1949 erfolgte die Gründung der DDR mit Ost-Berlin als Hauptstadt. Am 13. August 1961 begann der Bau der Berliner Mauer um West-Berlin, um den Wegzug der DDR-Bürger in den Westen zu unterbinden. Die Mauer war insgesamt 161 Kilometer lang, von denen sich 45 quer durch die Stadt zogen.

Das Brandenburger Tor bildet den westlichen Abschluss der Prachtstraße Unter den Linden. Von 1961 bis 1989 Symbol der geteilten Stadt, wurde es mit dem Fall der Mauer am 9. November 1989 zum Sinnbild des wiedervereinigten Deutschland. Carl Gotthard Langhans entwarf das Brandenburger Tor 1788 nach dem Vorbild der Propyläen auf der Athener Akropolis und als Ersatz für einen Vorgängerbau von 1735. Die Toranlage mit fünf Durchfahrten wurde 1789–91 ausgeführt und 1793 durch Gottfried Schadows (Entwurf) sechs Meter hohe Quadriga – der Siegesgöttin mit einem Viergespann – vollendet. Die ursprünglich als Wache und Steuerhaus genutzten seitlichen Bauten waren mit der alten Zollmauer verbunden und wurden nach deren Abbruch durch Heinrich Strack 1867–68 mit offenen Säulen im Westen zur Tiergartenseite umgestaltet. Der 1732–34 angelegte Platz – Pariser Platz – erhielt seinen Namen nach der alliierten Eroberung von Paris 1814. Denn 1806 war auf Befehl Napoleons nach der Niederlage Preußens die Quadriga nach Paris gebracht worden. Sie kehrte 1814 in einem Triumphzug nach Berlin zurück.

Brandenburg Gate

The GDR was formed in 1949, with East Berlin as its capital. On 13th August 1961, the construction of the Berlin Wall around West Berlin began in order to stop the emigration of the people of the GDR to the west. In total, the wall was 161 kilometres long, 45 kilometres of which ran right through the city.

The Brandenburg Gate forms the western end of the grand avenue 'Unter den Linden'. From 1961 to 1989 a symbol of the divided city, when the Wall came down on 9th November 1989 it became an emblem of the reunited Germany. Carl Gotthard Langhans designed the Brandenburg Gate in 1788 in the style of the Propylaea at the Acropolis in Athens as a replacement for an earlier structure dating from 1735. The gateway complex with its five thoroughfares was built from 1789–91 and completed in 1793 with the addition of the Quadriga, the seven-metre-high goddess of victory with carriage and four, designed by Gottfried Schadow. The side-buildings, originally used as a sentry post and tax house, used to be linked to the old customs wall. After this was demolished, they were remodelled by Heinrich Strack in 1867-68, with open columns added on the west side facing the Tiergarten.

After Prussia's defeat in 1806, Napoleon had ordered the 'Quadriga' be taken to Paris. Eight years later, in 1814 when Paris was taken by the allies, it returned in triumphal procession to Berlin, and this square, originally laid out in 1732–43, was given its name, 'Pariser Platz'.

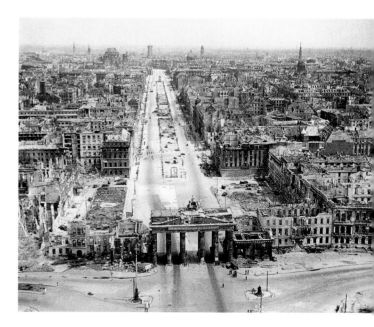

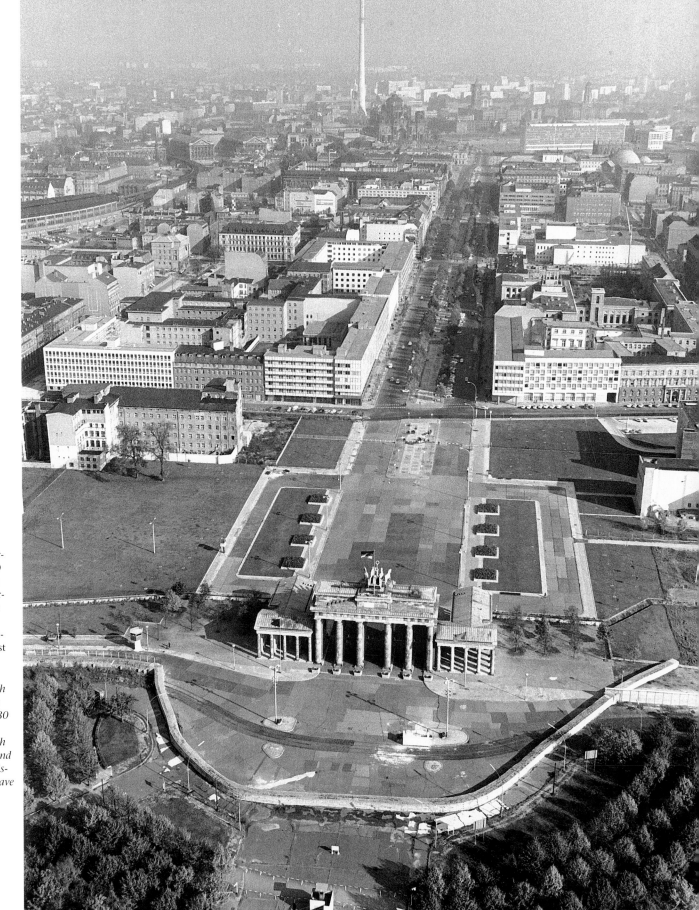

iser Platz mit
n Brandenbur-
Tor, um 1930
d 1945 (links)
vie den Mauer-
rranlagen der
liner Mauer
57. Die histori-
e Bebauung ist
stört (rechts).

iser Platz with
Brandenburg
te around 1930
d 1945 (left)
d in 1967 with
barriers around
Wall. The his-
c buildings have
n destroyed
ht)

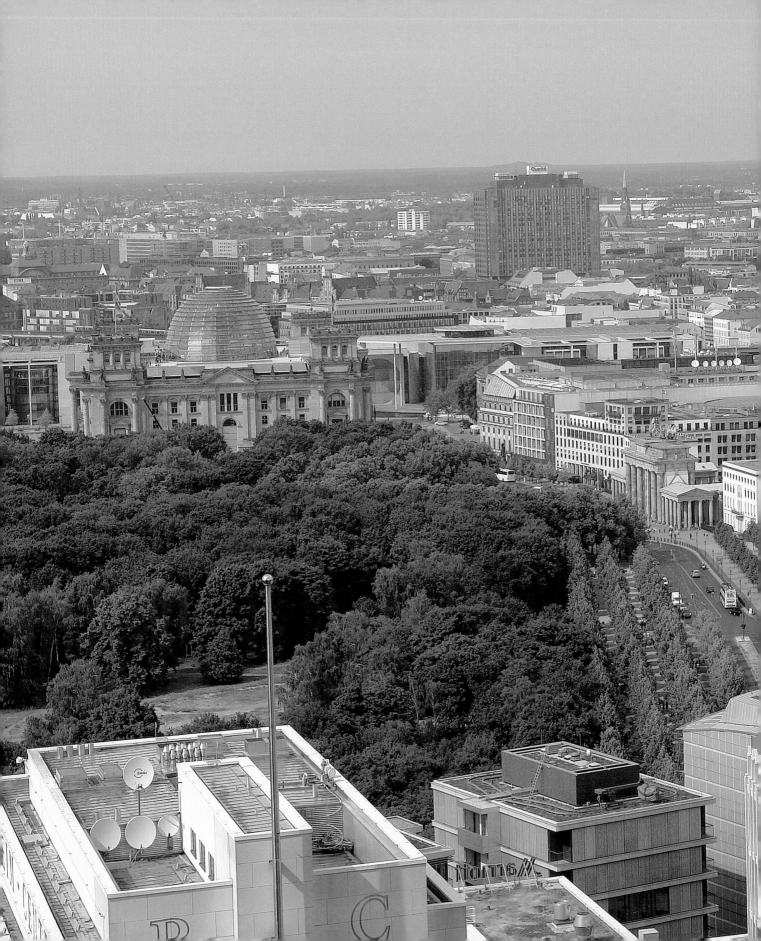

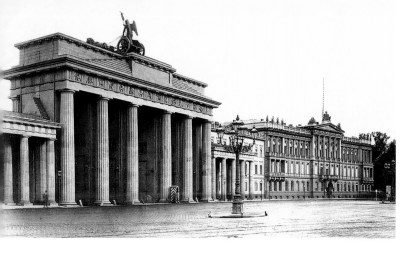

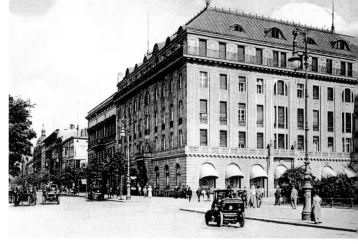

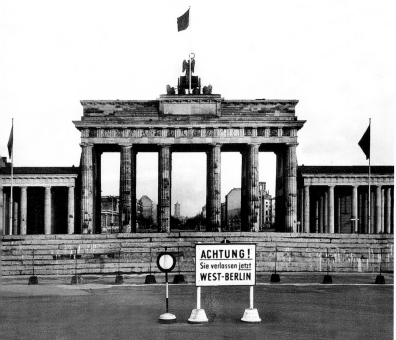

linke Spalte: Brandenburger Tor, Ansicht von Westen um 1930, um 1967 und heute
oben und unten: Hotel Adlon am Pariser Platz, um 1930, um 1946 und heute

left column: Brandenburg Gate, View from the West around 1930, 1967 and today
above and below: Hotel Adlon at the Pariser Platz around 1930, 1946 and today

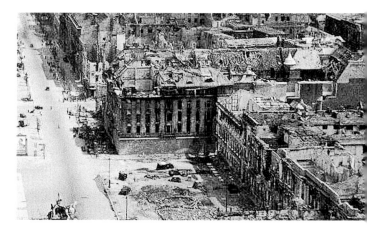

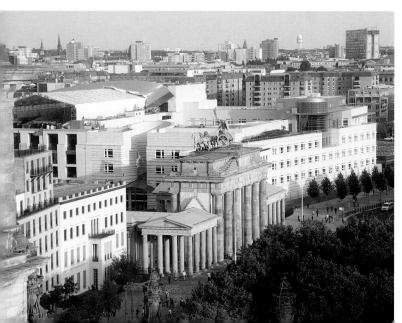

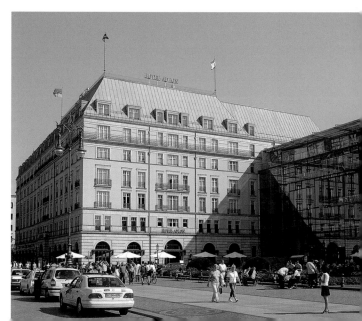

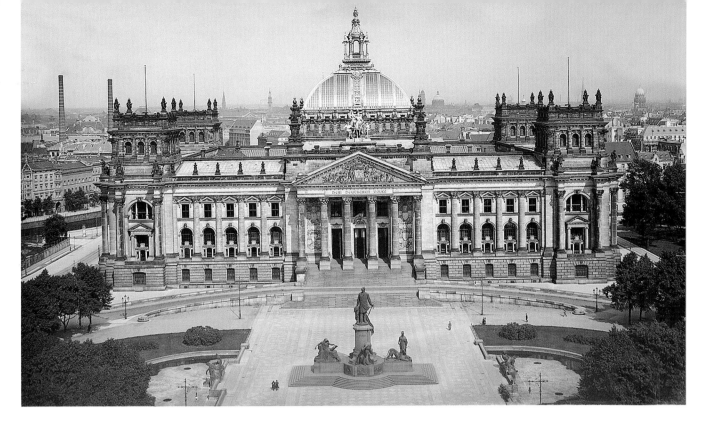

Das Reichstagsgebäude wurde 1884–94 nach Plänen von Paul Wallot errichtet. Stark kriegsbeschädigt, sprengte man 1954 die Kuppelreste und richtete ab 1961 das Gebäude nach Plänen Paul Baumgartens als Berliner Dependance des Bundestages (seit 1972) und als Tagungs- und Ausstellungsort ein. Nach dem Umzugsbeschluss des Bundestags am 29.10.1991 erhielt 1993 der englische Architekt Sir Norman Foster den Auftrag für den Umbau zum Deutschen Bundestag mit der heutigen Glaskuppel.

The Reichstag building was built in 1884–94 to plans by Paul Wallot. Having been badly damaged in the War, what was left of the copula was blown up in 1954. In the years from 1961, the building was reconfigured to plans by Paul Baumgarten as a conference and exhibitions venue and (from 1972) as Berlin's venue for occasional sessions of the Bundestag (German Parliament). Following the decision taken on 29th October 1991 to relocate the Bundestag to Berlin, English architect Sir Norman Foster was commissioned in 1993 to convert the building into the 'Deutscher Bundestag' with its new glass copula.

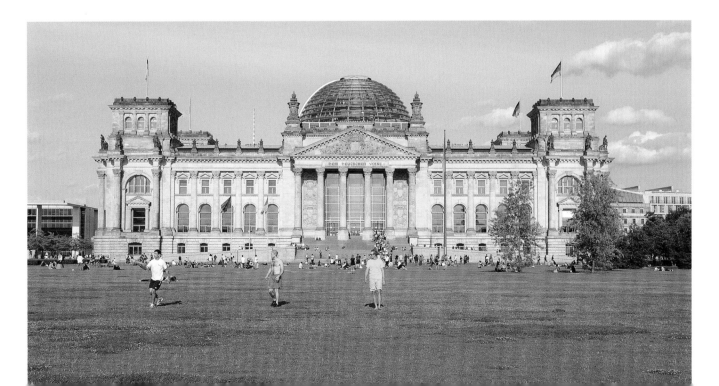

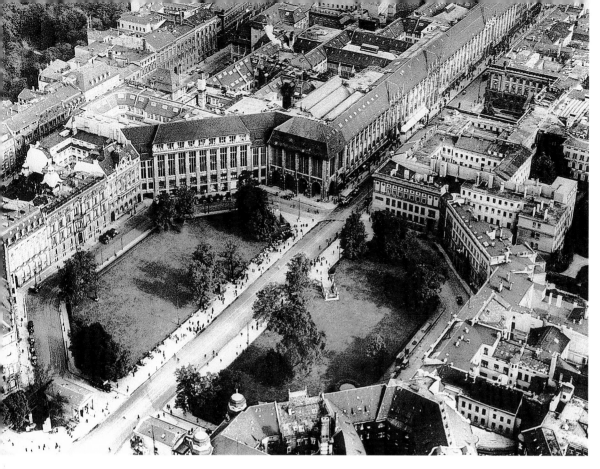

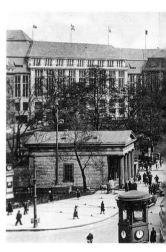

Leipziger Platz, der sich dem Potsdamer Platz anschließt, um 1900/10 (oben), um 1950 (unten links) und um 1965 (unten rechts)
Leipziger Platz, which connects to Potsdamer Platz, around 1900/10 (above), around 1950 (below left) and around 1965 (below right)

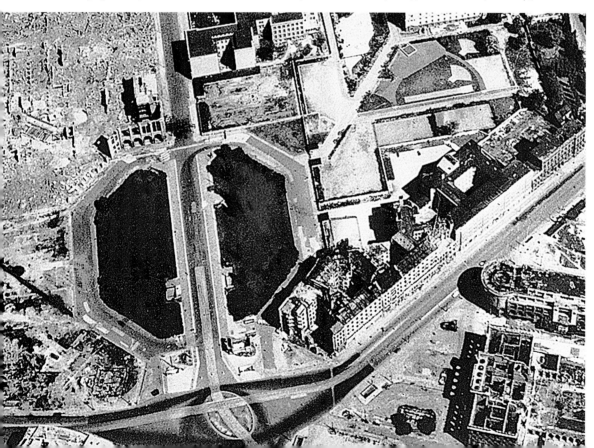

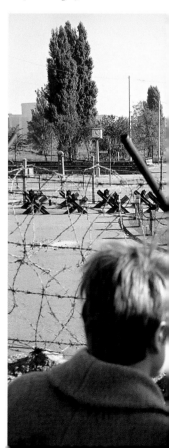

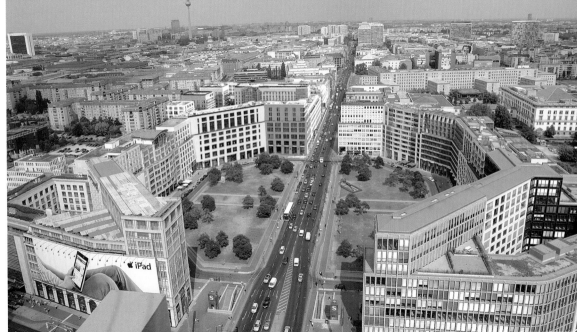

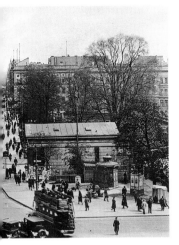

Potsdamer Platz

Leipziger/Potsdamer Platz um 1962 (unten) und heute (oben). Bis zum 2. Weltkrieg waren der Potsdamer/Leipziger Platz einer der verkehrsreichsten Plätze Europas. Nach Kriegsende lag der Platz zur Hälfte in Trümmern. Nach ersten Aufbauarbeiten führte die Errichtung der Berliner Mauer 1961 zur endgültigen Zerstörung der Platzanlage, um den Sperranlagen Platz zu machen. Nach dem Fall der Mauer 1989 begann ab 1998 der Wiederaufbau.

Leipziger/Potsdamer Platz around 1962 (below) and today (above). Until World War II, Potsdamer/Leipziger Platz was one of the busiest squares in Europe. After the end of the war, half of the square was in ruins. After initial rebuilding, the construction of the Berlin Wall led to the final destruction of the square in order to make room for the border installations. Reconstruction began again in 1998 after the Berlin Wall fell in 1989.

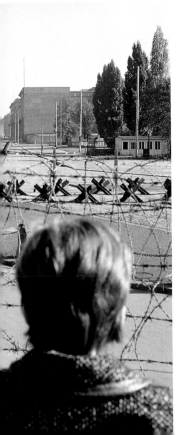

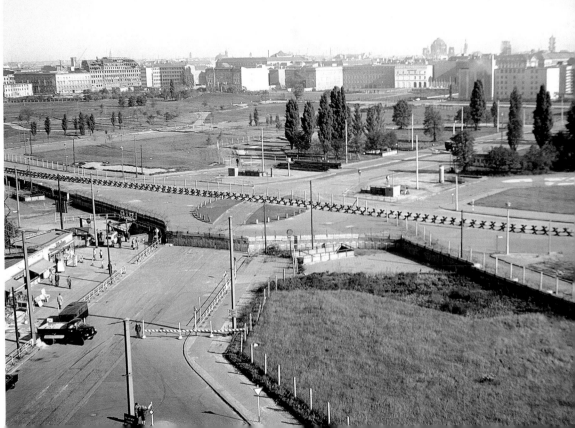

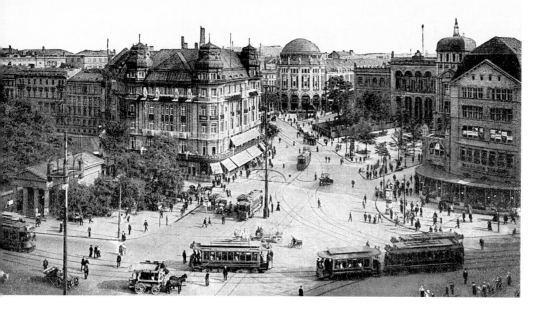

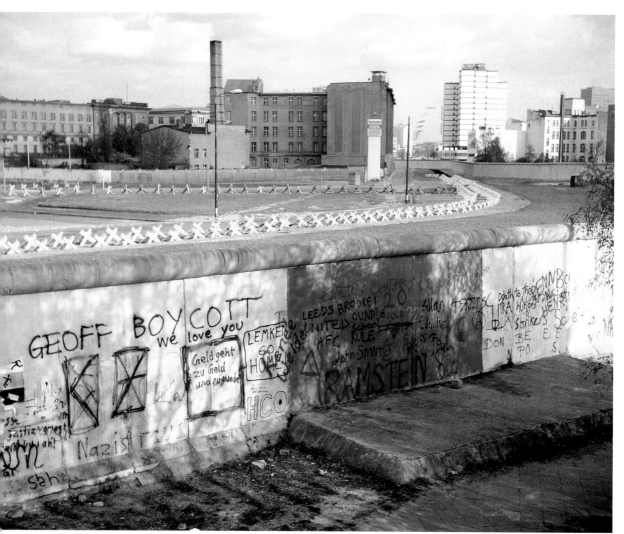

Blick vom Potsdamer
Platz zum ehemaligen
Potsdamer Bahnhof
um 1910 (oben links),
um 1975 (links) und
heutige Situation (oben)

*View from the Potsdamer
Platz to the former
Potsdamer railway station
around 1910 (above left),
around 1975 (left) and
today's scene (above)*

unten: Potsdamer Platz,
Reste der Berliner Mauer
heute
*below: Potsdamer Platz,
Berlin Wall today*

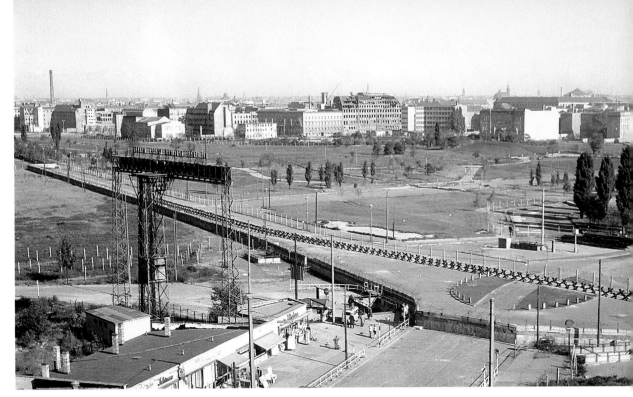

rechts: Blick vom
Potsdamer Platz zum
Pariser Platz um 1962
(oben) und heute
(unten)

*right: View from the
Potsdamer Platz to the
Pariser Platz around
1962 (above) and
today (below)*

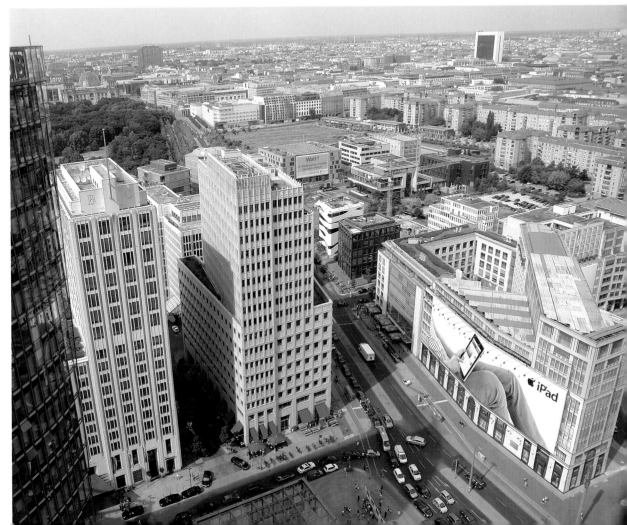

Potsdamer Platz mit Haus Vaterland um 1915 (oben) und heutige Situation (oben rechts) sowie dem Potsdamer Bahnhof um 1915 (unten) und heutige Situation (unten rechts)

Potsdamer Platz with 'Haus Vaterland' around 1915 (above left) and today's scene (above) and Potsdam Railway Station around 1915 (below left) and today's scene (below right)

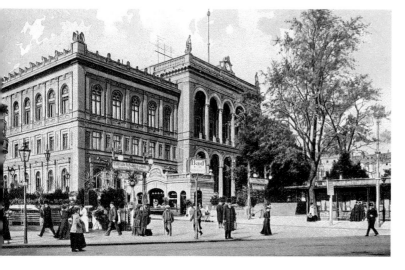

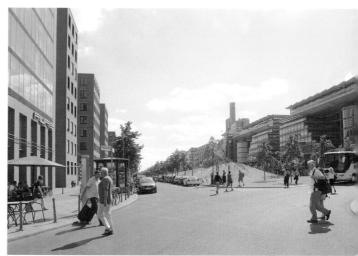

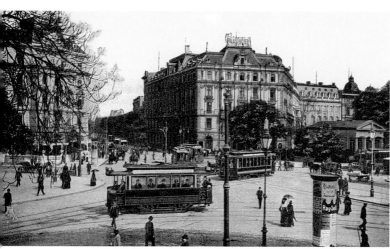

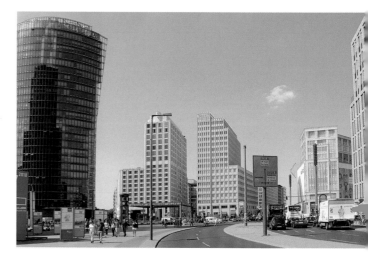

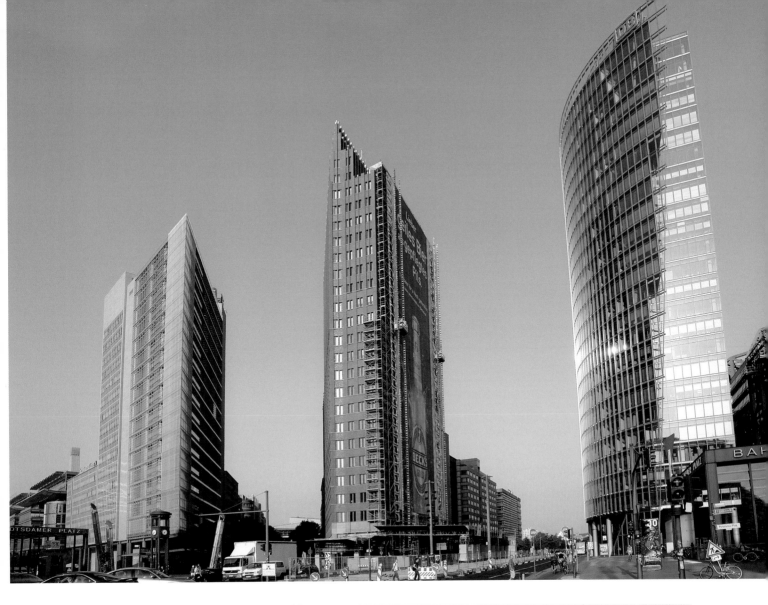

oben und rechts: Potsdamer Platz mit Blick zur Pots-
damer Straße um 1910 und heute (mit dem 103 m
hohen gläsernen Sony-Turm von Helmut Jahn, dem
88 m hohen Klinker-Hochhaus von Hans Kollhoff &
Timmermann und dem ockerfarbenen Hochhaus von
Renzo Piano, 1994–99)
above and right: Potsdamer Platz, view to the Potsdamer
Straße around 1910 and today (with the 103-metre-high,
glass Sony tower, the 88-metre clinker tower by Hans
Kollhoff & Timmermann and the ochre-coloured tower by
Renzo Piano, 1994–99)

links: Potsdamer Platz mit Blick nach Norden Rich-
tung Brandenburger Tor um 1910 und heute
left: Potsdamer Platz, view to the north to the Branden-
burg Gate today and around 1910

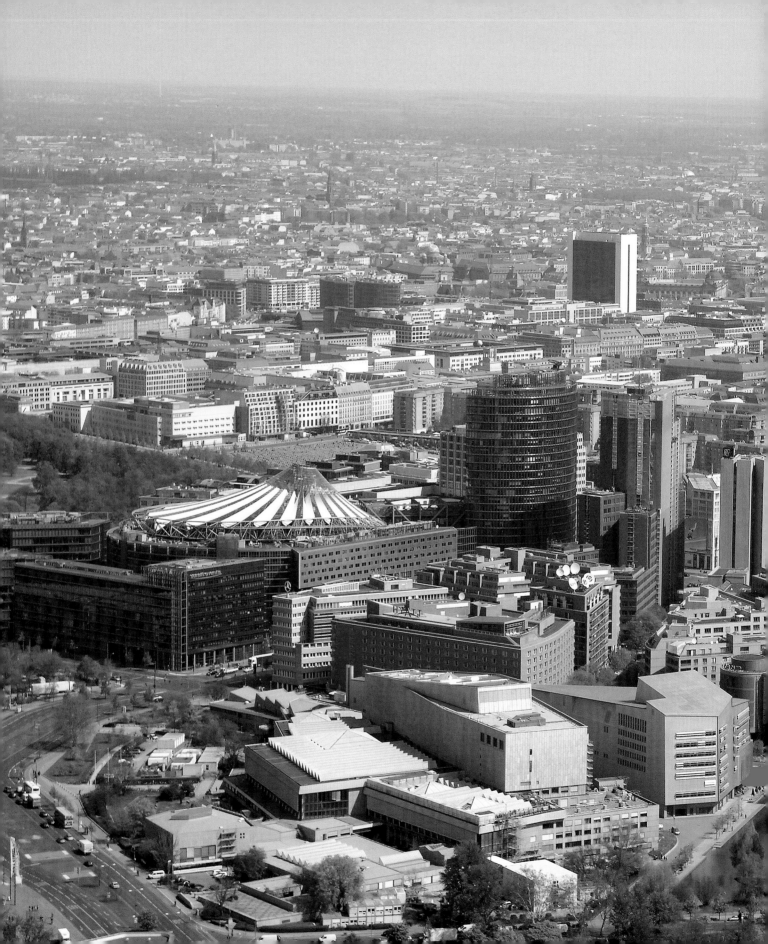

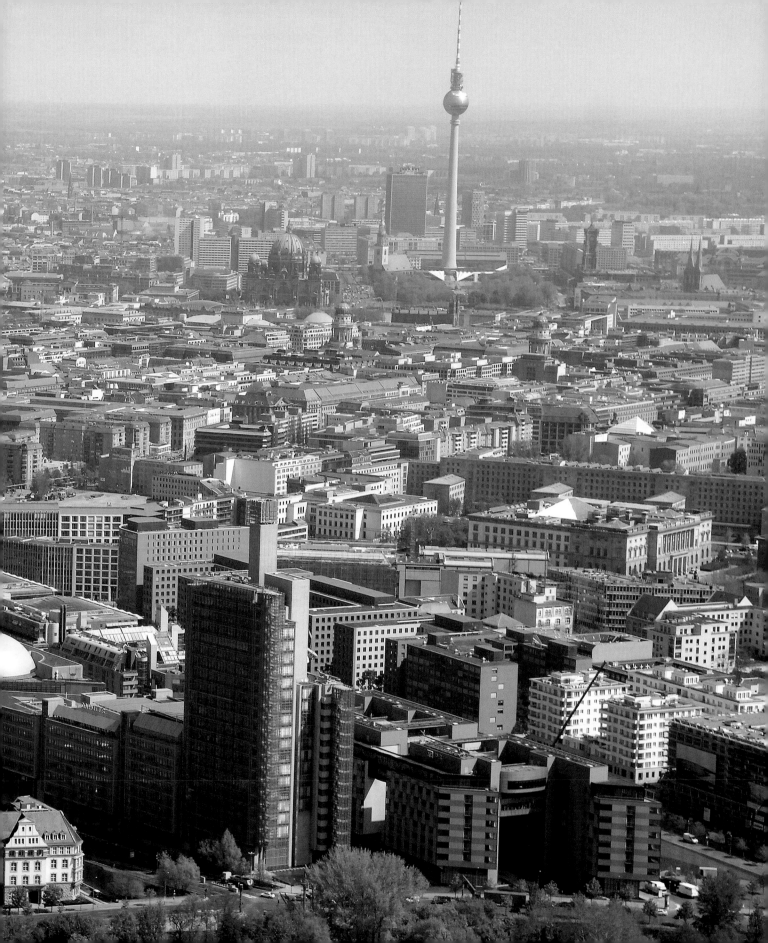

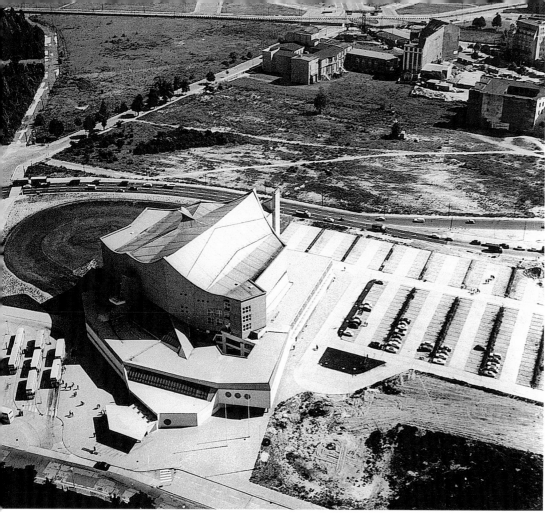

S. 108/109: Luftbild vom Potsdamer Platz-Areal heute
page 108/109: aerial view of Potsdamer Platz today

links: Philharmonie, 1960–63 von Hans Scharoun. Luftbild um 1965 mit dem im 2. Weltrieg großflächig zerstörten und anschließend beräumten Gelände um den Potsdamer Platz mit der Berliner Mauer am oberen Bildrand
unten: Blick vom Kulturforum mit der Philharmonie links zum Potsdamer Platz heute
left: Philharmonie, 1960–63 by Hans Scharoun. Aerial photograph around 1965 with the grounds around Potsdamer Platz that were extensively destroyed in World War II and then vacated with the Berlin Wall at theupper edge of the picture
below: view from the Kulturforum toward the Potsdamer Platz with the Philharmonie on the left today

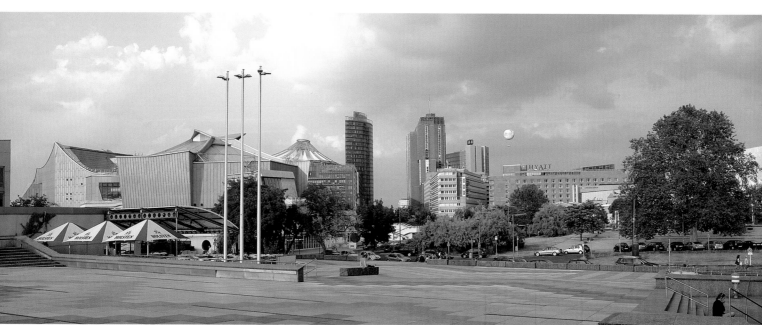

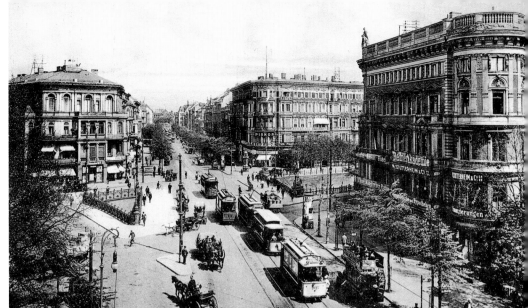

oben und unten: St. Matthäus-Kirche, 1844–46,
mit Randbebauung um 1915 und heute
rechts: Potsdamer Straße mit Potsdamer Brücke
um 1915 (oben), Luftaufnahme von 1945 (Mitte)
und heutige Situation (unten)
above and below: St. Matthäus-Kirche, 1844–46,
with peripheral development around 1915 and today
right: Potsdamer Straße with Potsdamer Brücke
around 1915 (above), aerial photograph from 1945
(center) and today's scene (below)

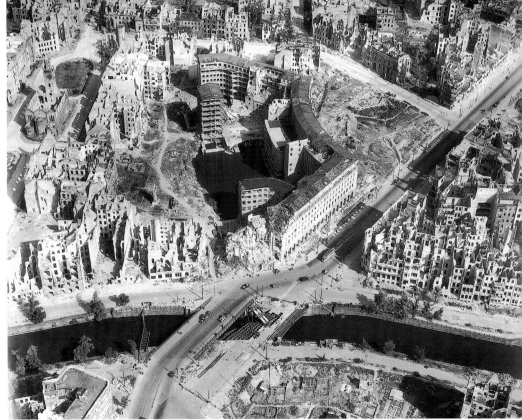

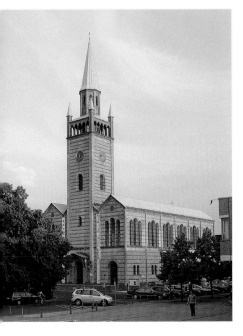

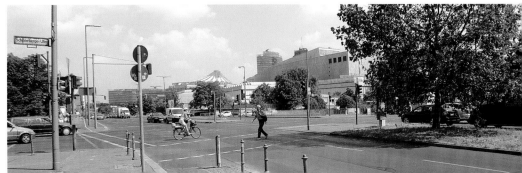

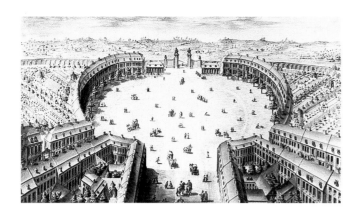

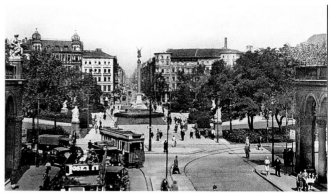

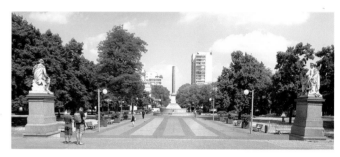

Der Belle-Alliance-Platz (heute Mehringplatz) liegt in Berlin-Kreuz-
berg und ist einer von drei bedeutenden Plätzen, die bei der Stadter-
weiterung Berlins um 1730 angelegt wurden (Ansicht um 1750 mit
Blick nach Süden, Foto oben links). Er bildet den südlichen End-
punkt der Friedrichstraße. Den Platzmittelpunkt bildet ein Brunnen
mit der 1843 errichteten Friedenssäule (Foto um 1900 oben rechts).
Im 2. Weltkrieg wurde der Platz vollständig zerstört (Abb. unten)
und mit geänderter Straßenführung und neuer Bebauung wieder-
aufgebaut (Foto rechts).

*Belle-Alliance-Platz (today Mehringplatz) is located in Berlin-Kreuzberg-
and is one of three important squares, which were created when the city of
Berlin was expanded around 1730 (view around 1750 looking toward the
south, photo above left). It forms the southern end of Friedrichstraße.*

*A fountain with the Friedenssäule built in 1843 forms the center of the
square (photo around 1900 above right). The square was completely
destroyed in World War II (photo below left) and rebuilt with a different
street arrangement and new buildings (photo above).*

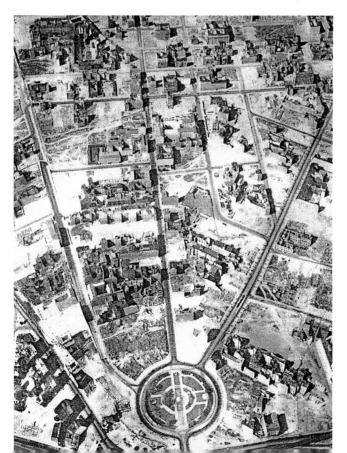

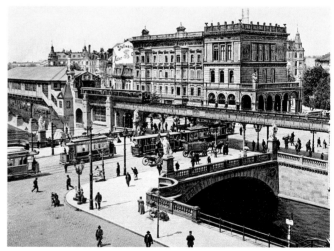

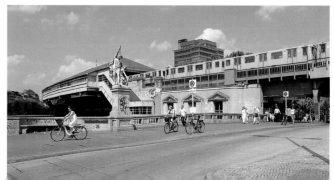

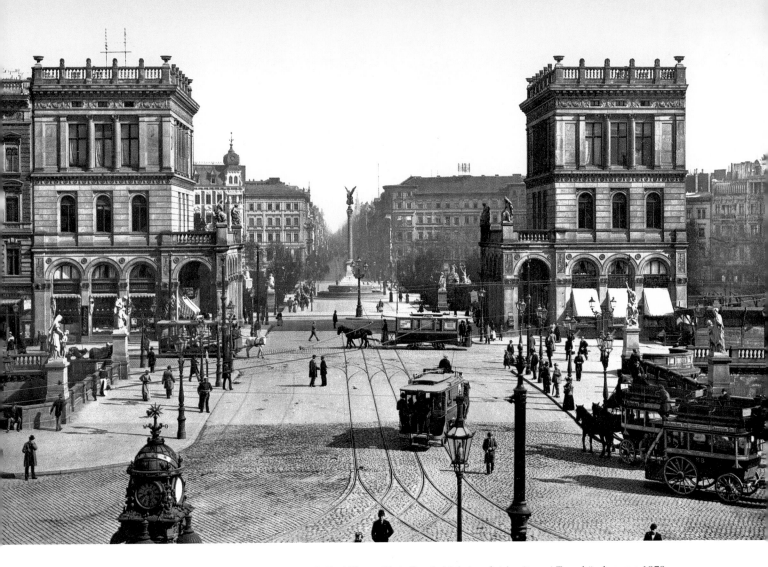

oben und S. 112 unten rechts: Hallesches Tor, Zugang zum Belle-Alliance-Platz (heute Mehringplatz) mit zwei Torgebäuden von 1879, die Heinrich Strack an Stelle des einstigen Tores entwarf (oben) und heutiger Zustand (unten)
above and page 112 below right: Hallesches Tor, gateway to the Belle-Alliance-Platz (today Mehringplatz) with two gate buildings from 1879, which were designed by Heinrich Strack to replace the former gate (above) and condition today (below)

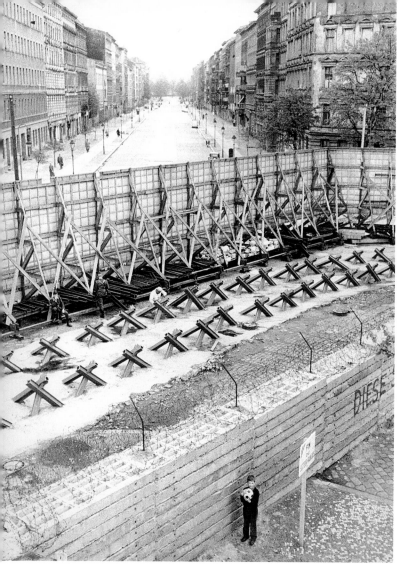

Bernauer Straße

Am 13. August 1961 sperrten DDR-Grenzsoldaten den Zugang von Ost- nach Westberlin und begannen mit der Errichtung der Berliner Mauer, um den Flüchtlingsstrom der DDR-Bürger in den Westen zu unterbinden. Die Mauer sollte bis November 1989 bestehen bleiben und Berlin teilen. In der Bernauer Straße verlief die Grenze entlang der südlichen Häuserbebauung. Deshalb flüchteten die Anwohner dieser Häuser durch diese Wohnungen, die zunächst vermauert und 1965 gesprengt wurden, um Platz für den Todesstreifen zu schaffen.

On August 13, 1961, GDR-border soldiers blocked access from East Berlin to West Berlin and began to construct the Berlin Wall, in order to stop the flight of GDR-citizens to the west. The wall would remain in place until November 1989 and divide Berlin. On Bernauer Straße, the border ran along the southern row of houses. For this reason, the residents fled through these houses, which were first walled up and then demolished in 1965 to make room for the death strip.

Bernauer Straße Ende 1962 mit Berliner Mauer (links) und vermauerten Fenstern, links die Sperrmauer (unten) und heutige Situation (unten links)
Bernauer Strasse at the end of 1962 with the Berlin Wall (left) and bricked-up windows; the Wall can be seen on the left (below) and today's scene (below left)

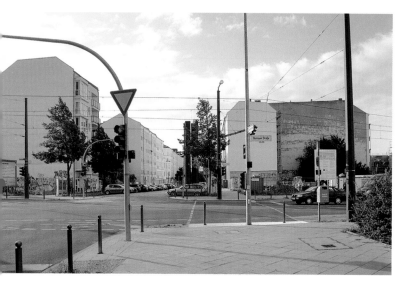

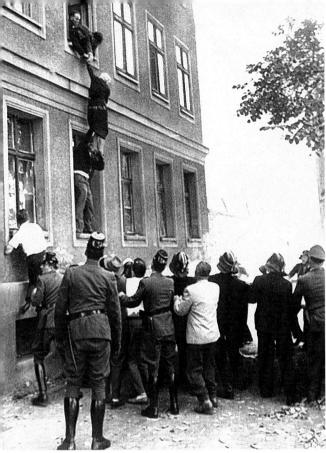

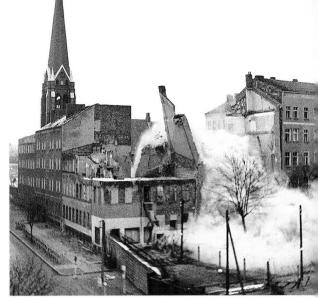

rechts und unten: Bernauer Straße am 29. Dezember 1965, Sprengung der Häuser auf der Ostberliner Seite für die Berliner Mauer mit Todesstreifen
right and below: Bernauer Strasse on 29 December 1965. Demolition of buildings on the East-Berlin side to make room for the Berlin Wall

Bernauer Straße im September 1961: Eine 77-jährige Frau flüchtet aus ihrem Fenster in den Westteil der Stadt. SED-Ordner versuchen, sie wieder in das Fenster hineinzuziehen.
Bernauer Strasse, September 1961: A 77-old woman escapes from her window into West Berlin, as SED officials seek to pull her back.

unten links: Bernauer Straße 1962 mit vermauerten Fenstern
unten rechts: Sprengung der Versöhnungskirche am 22.1.1985
below left: Bernauer Strasse 1962 with bricked-up windows
below right: Demolition of the Church of Reconciliation on January 22, 1985

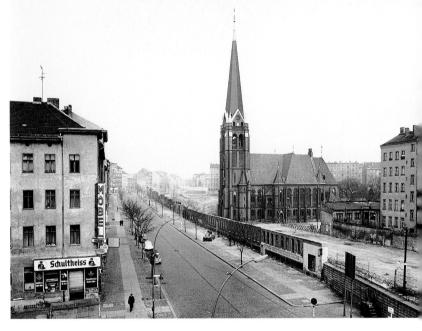

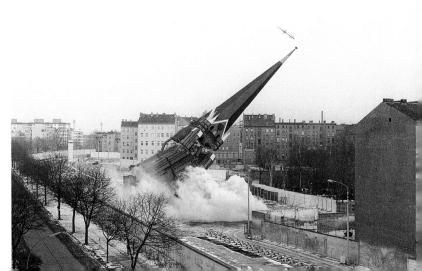

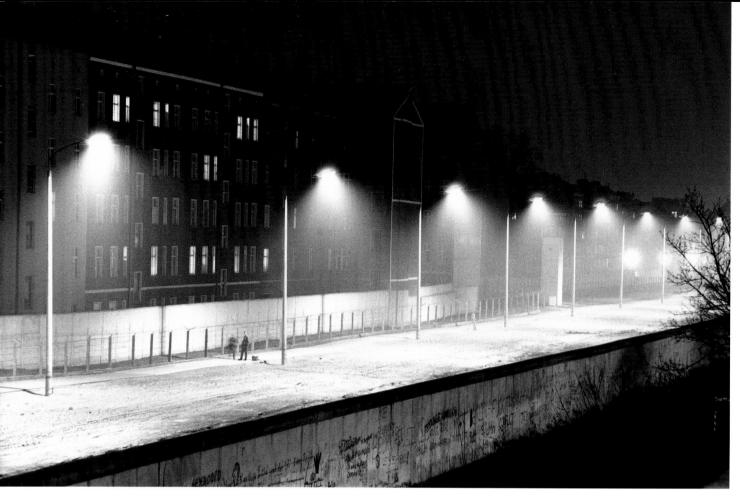

Berliner Mauer an der Bernauer Straße, Nachtaufnahme der Grenzanlagen 1986
Berlin Wall on Bernauer Strasse, night view of the border installations, 1986

unten: Ehemaliger Mauerstreifen an der Bernauer Straße, heute Teil der Gedenkstätte Berliner Mauer mit der Kapelle der Versöhnung von Martin Rauch, die 2000 auf dem Fundament der Versöhnungskirche in Lehmbauweise gebaut wurde
below: Piece of the former wall on Bernauer Straße, today part of the Berlin Wall Memorial with the Chapel of Reconciliation by Martin Rauch, which was built in 2000 with loam construction on the foundation of the Versöhnungskirche

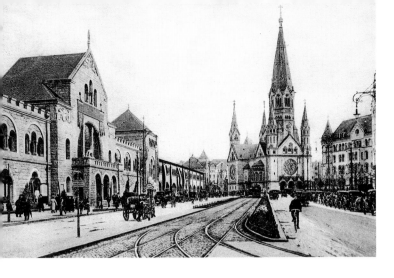

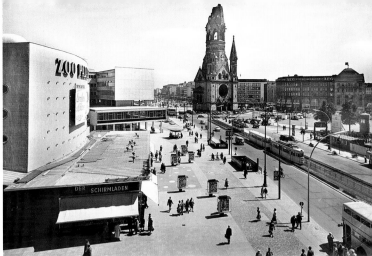

Kaiser-Wilhelm-Gedächtniskirche, 1891–95 als neoromanische Kirche von Franz Heinrich Schwechten erbaut, Ansicht um 1905 (oben) und nach den Kriegszerstörungen im 2. Weltkrieg um 1946 (unten), Zustand um 1955 (oben rechts) und heute mit den Neubauten von Egon Eiermann 1957–63 (rechts)

Kaiser-Wilhelm-Gedächtnis-Kirche, Franz Heinrich Schwechten's Neo-Romanesque church dating from 1891–95, photo around 1905 (above), around after the World War II around 1946 (below), around 1955 (below right) and today with the new buildings by Egon Eiermann, 1957–63 (right)

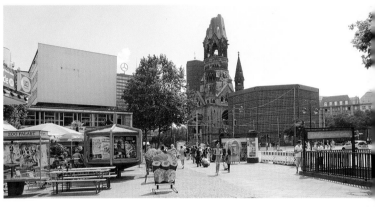

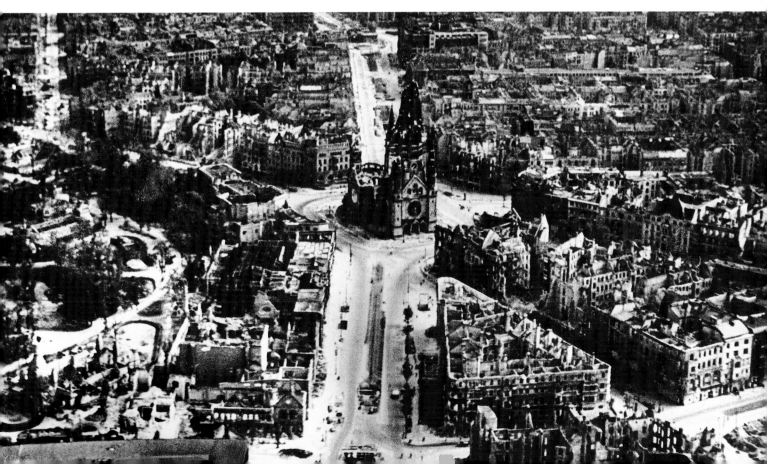

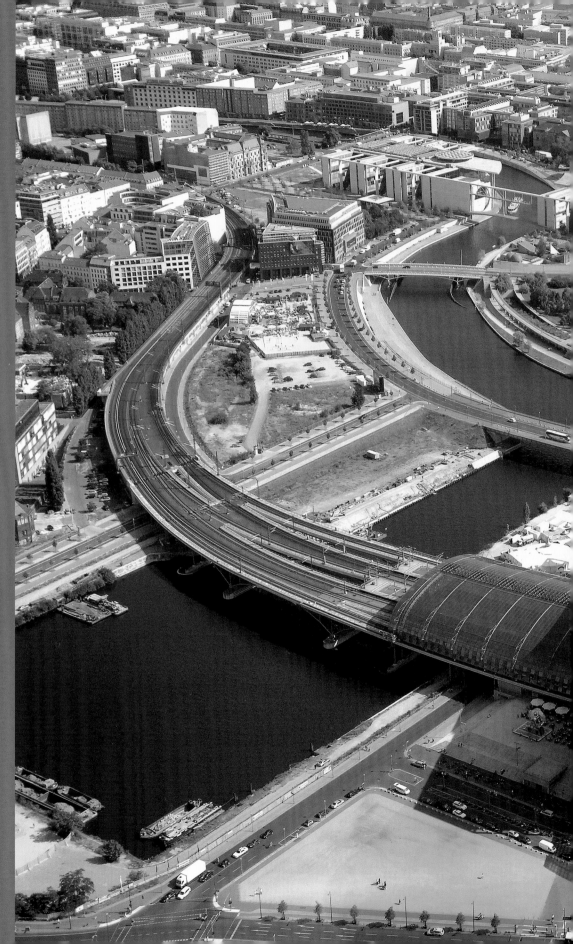

Blick vom
Lehrter Bahnhof
2010

*View from Lehrter Bahnhof
toward Brandenburg Gate
in 2010*